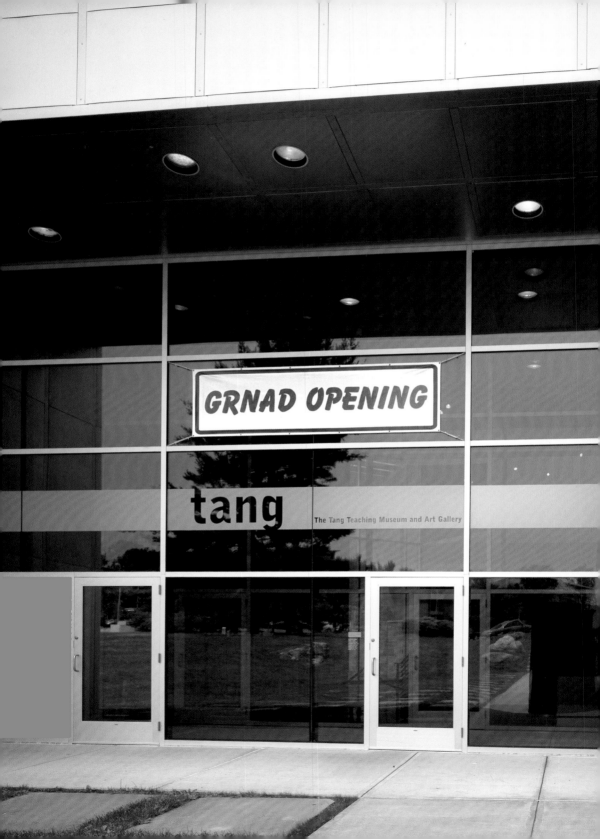

# NINA KATCHADOURIAN

## *ALL FORMS OF ATTRACTION*

IAN BERRY

with an essay by FRANCES RICHARD

THE FRANCES YOUNG TANG TEACHING MUSEUM AND ART GALLERY

AT SKIDMORE COLLEGE

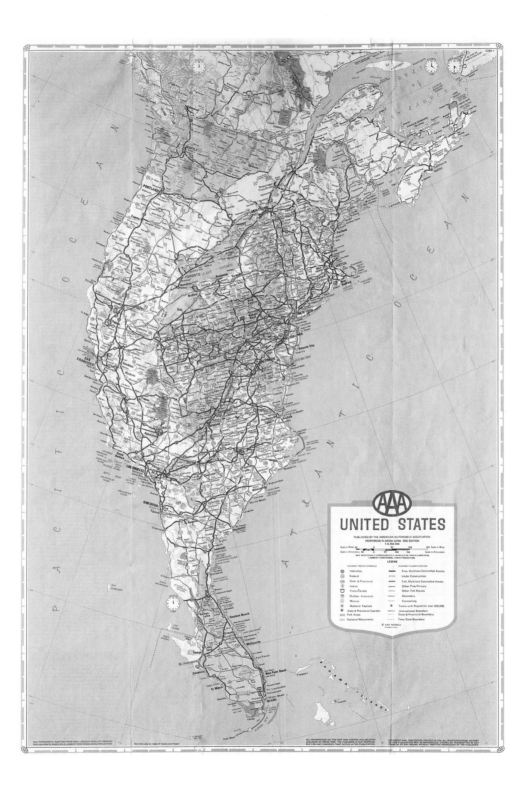

# UNITED STATES

PUBLISHED BY THE AMERICAN AUTOMOBILE ASSOCIATION
HEATHROW, FLORIDA 32746  1992 EDITION
1:5,792,000

Scale in Miles  Scale in Map
Scale in Kilometers  Scale in Kilometers
ONE INCH EQUALS APPROXIMATELY 92 MILES OR 148.5 KILOMETERS
LAMBERT CONFORMAL CONIC PROJECTION

## LEGEND

**HIGHWAY ROUTE SYMBOLS**

- Interstate
- Federal
- State & Provincial
- Indian
- Trans-Canada
- Québec Autoroute
- Mexico
- National Capitals
- State & Provincial Capitals
- Park Areas
- National Monuments

**HIGHWAY CLASSIFICATION**

- Free, Multilane Controlled Access
- Under Construction
- Toll, Multilane Controlled Access
- Other Free Primary
- Other Toll Routes
- Secondary
- Connecting
- Towns with Population over 200,000
- International Boundary
- State & Provincial Boundary
- Time Zone Boundary

# PAYING ATTENTION

## A Dialogue with NINA KATCHADOURIAN by Ian Berry

Nina Katchadourian makes engaging and irreverent artworks that combine investigative practices with a more elusive, poetic logic. Incorporating sculpture, photography, video, and sound, her multi-layered projects are propelled by deliberate attempts to observe, scrutinize, order, and disorder her surroundings. She creates works from meticulously dissected road maps that re-imagine our collective geography. Other pieces witness the artist's often meddlesome relationship to the natural world, exposing the insight gained through misunderstanding natural phenomena. Linguistic systems, mistranslation, taxonomy, and kinship also rank high among her fascinations. Working with ideas that spring from details of everyday life, Katchadourian focuses our gaze on what is always under foot.

**IAN BERRY:** You combine many disciplines and interrogate a wide variety of ideas in your work. Have you always worked this way?

**NINA KATCHADOURIAN:** Yes, it's been this way since college. I double-majored in visual art and in a department called "Literature and Society," which combined history, literature, and theory, so I have felt like an interdisciplinary creature from the beginning. Crossover seems to be present anywhere you look in my life: my family, the way I work, the media I take up, the subject matter that comes into play.

**IB:** For you, "interdisciplinary" is a natural part of your process.

**NK:** I can't help it, it is what comes out. The first art piece I made that I felt was significant was a paper world map that was gradually cut apart and reassembled. It was a reconfigured version of the world that fit together very convincingly and comfortably even though everything was wrong.

(facing page)
*Coastal Merger*, 1993
Reassembled paper map
24 1/4 x 16 3/8"
Collection of the artist

(previous page)
*Grnad Opening Banner*, 2006
Vinyl
36 x 120"
Installation view, Tang Museum,
Skidmore College, 2006

**IB:** When did you make that?

**NK:** In 1989, when I was a senior at Brown University.

**IB:** Maps come up repeatedly for you. Is your interest in the maps themselves, as objects, or in the idea of what a map represents?

**NK:** I think of it in two parts. The reason for choosing the map as a form has to do with the fact that they look true. People see maps and tend to believe what they are shown because the form is familiar and it looks objective. That is the same reason I like to make charts and family trees or pieces like *Paranormal Postcards*. When you first encounter a piece like that it looks like something that is trying to impart information in a way that will be logical, that will fall into line with a system that is familiar. But the piece doesn't behave that way, it switches its forms of logic, it makes connections based on shifting criteria, which flies in the face of what an informational system should do. The other part is about the process of dissecting or disassembling something factual and practical and turning it into something that is very handmade and personal and non-functional. *Handheld Subway* is absolutely useless as a map, but to me accurately describes the experience of trying to deal with a complicated transportation network.

**IB:** Is that what you gain from making useful things un-useful? Do you gain some way of communicating a more true reality of what they represent?

**NK:** It gets closer to an experience-based reality.

**IB:** You employ structures for categorizing and sorting—functions that we normally associate with clarity, recording, and a sort of calm.

**NK:** Putting things in the right place.

**IB:** Right, making us feel settled. Yet what you produce are things that are unsettled or potentially confusing.

**NK:** Or maybe they show you something that has been in between, in the cracks, something you haven't noticed before. With *Indecision on the Moon*, for example, I edited out all the coherent language from the audio recording of the Apollo 11 moon walk. What you are left with are the "in between" sounds, the ones that feel "non-informational": radio static, "uhs" and "ums," and sentences that trail off, and questions that are half-posed or half-answered. All those sounds were there already, I just lifted them forward. When they are foregrounded in this way they seem to suggest a very different feeling, this indecision or insecurity, inside an important American moment.

**IB:** When looking at your past work, another thing that comes up is your use of found materials—found audiotape, videotape, postcards, road maps, things in nature like leaves and spiders, and also found language. Are you trying to focus us on things that we usually walk by and do not notice?

*Transplant*, 1999
Cibachrome (left) and plant
fragment with insect wings (right)
Each 10 x 7 1/4 x 1 3/4" framed
Collection of Ralph and Sheila
Pickett, Saratoga, California

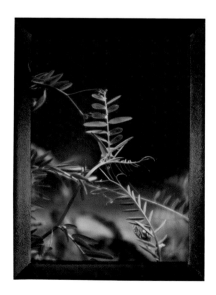

**NK:** That is definitely part of it, but I think finding things is also the result of trying to pay attention to things. It has to do with the mind-set of trying to be alert to things that you are passing over all the time. The *Moss Maps* photographs are a good example. There are patches of lichen that grow on a big hill on the island in Finland where I've been spending summers with my family, and I had been walking up this huge rock hill for twenty-five years of my life, looking at these little things on the ground and always thinking the same thing: that patch looks like Australia, that one looks like the Canary Islands, and so on. I suddenly realized that the only move that needed to happen was to label them as those things so that someone else could recognize them as such. I seem to do that a lot, the "let me show you what I have been noticing" strategy.

**IB:** Should we be noticing more?

**NK:** I think the world is a lot more interesting when you notice more. I am really happy when people come to me after seeing a piece and tell me they have started noticing things differently. With *Natural Car Alarms* people have often remarked that they don't hear a car alarm the same way anymore. That makes me feel like a loop has been successfully completed.

**IB:** Do you enjoy your work serving as a catalyst for some other action that happens outside your production rather than your work being the end product?

**NK:** In some sense I feel I have succeeded when some thought process or activity gets put into motion for the viewer as a result of having seen one of my projects.

**IB:** Do you think of your work, then, in the Duchampian model of "the viewer completes the work?"

**NK:** I would say that it is a little bit oblique to that, but I wouldn't be doing any of this stuff if it wasn't about having a conversation.

(facing page)
*Hawaii* and *Australia* from the *Moss Maps* series, 1993
Fourteen c-prints, each 14 x 20"

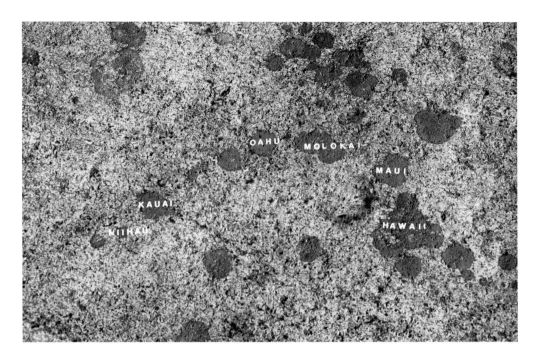

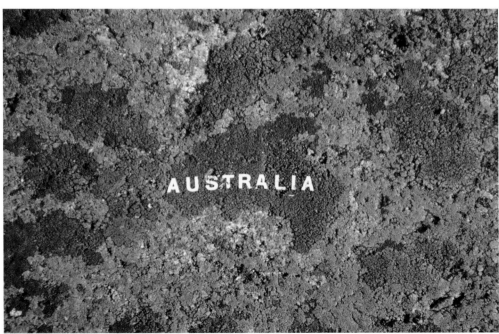

9

It would be utterly uninteresting to me if no one saw it. It is about active communication. Making the stuff and putting it out there is one step, and then the next step is the feedback or the conversation. The process for me doesn't end at the point when work hangs on the wall. It also includes what happens after that, what people think and say and tell me, and also my chance to see whether what I thought they would think turned out to be correct.

**IB:** How did the *Mended Spiderwebs* project begin?

**NK:** My great grandfather on my mother's side decided he wanted to find a summer place for his family, so he rowed from Helsinki out to the island of Pörtö, which took about seven hours. He picked it based on a good guess off the sea chart. He found a house that they could rent and so they started spending summers there. When my grandmother was grown she started bringing her family there and then my parents did the same thing. It was very forma-tive for me as a kid because we would wind up there for two or three months of the year. In the beginning there wasn't electricity or running water or anything, so we spent a lot of time doing daily

*Do-it-yourself Spiderweb Repair Kit,* 1998
Plexiglas box; scissors; tweezers; polyvinyl acetate glue; short, medium, and long pieces of Mölnlycke Tvättäkta red sewing thread #342
1¹/₂ x 8³/₈ x 4⁵/₈"
Collection of Richard and Lenore Niles, San Francisco, California

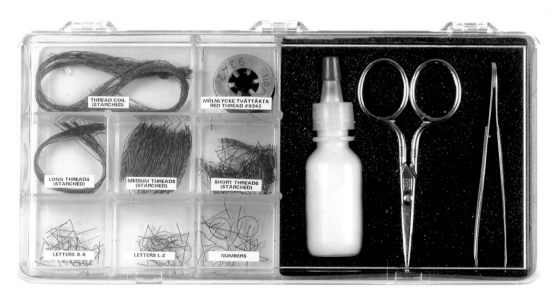

things and chores just to make life happen. There were lots of games, elaborate games that I would play with my brother. In the early years my mother's parents were spending a lot of time out there too. I think they have had a huge effect on my work, because of the way that I saw them observing the natural world there.

IB: Your parents?

NK: My mother's parents, my maternal grandparents. They would obsessively record all kinds of stuff that would happen there. My grandfather would take daily barometer readings, he would listen to the weather report five times a day, he knew the Latin names of every plant and every tree, he knew birds and where they nested. We found an incredible chart he made of every birdhouse on the property and what had nested there year after year after year for decades. He was a maniacal record keeper, as was my grandmother. In some ways her method was more about rendering the natural world. She was an artist: she used to draw tiny, careful studies of plants and amazing pen and ink sketches with the thinnest nib pen, where you can sense her looking very carefully at things. I know they had a huge impact on the way that I experience that island. I have been taught to look at it very carefully. It's not like they took me by the hand and brought me into the forest and said "Observe," but it was about watching their relationship to things, observing the way they observed.

IB: On one of your trips you decided to fix a broken spider web?

NK: On one of my trips I had a couple of weeks there on my own. There were a lot of moments of literally playing around in the forest, and it's probably significant that I had spent all this time on this island as a kid doing that too. So I was tracking ants and watching tadpoles and trying to follow through on impulses. And there was a slightly bratty moment of throwing something into a spider's web and watching how the spider would come and take it out.

**IB:** Did you know that a spider would actually collaborate with you on this?

**NK:** No, I didn't know that it would. I knew that they liked to get rid of objects that land in their web. But my impulse to repair the web and the observation that spiders clean up their webs had not completely come together when I started. I initially reacted to the fact that these spider webs looked broken, and I deliberately picked a method of fixing them that was very human: darning, stitching, or sewing—but these methods are also connected to a spider's act of spinning or weaving. I picked a material that would be on the one hand appropriate, it is thread, and spiders use thread, but on the other hand it was inappropriate because the thread was bright red and very visible. The spider and I had adjacent strategies, and then I knew of course that what I was doing was ultimately not really going to solve the spider's problem, that I wasn't really help-ing, and the project really only got interesting to me when the spider kicked the stuff out. That's when it felt like something was happening that had implications.

**IB:** How long did it take?

**NK:** The patches had been kicked out the very next day. I would come back the next morning and find patches lying on the ground and the spider's web fixed again, by the spider. The hole had been mended, and it kind of clicked that of course the spider must be the one doing this. Then I wanted to catch it in the act. That's why the video *GIFT/GIFT* was such a miraculous moment for me because I expected it to play out the same way, where the spider would clean up while I was gone and not watching. But this was the only time and the only take when the spider actually came back and did its clean-up job while I was watching. The experience of making that video was incredible because I had done my part, I had written the word "gift" by inserting these tiny thread letters, and then I just watched as the spider did its part. I was just a spectator at that point.

**IB:** Why the word "gift?"

**NK:** In Swedish, which is the language I grew up speaking at home with my mom, "gift" means poison, and I liked the idea that there would be this two-part meaning to the word. On the one hand I am giving the spider a present, but on the other hand it might be something harmful or unwanted.

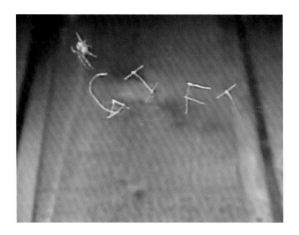

Still from *GIFT/GIFT*, 1998
Video
11:55 minutes
Collection of Richard and
Lenore Niles, San Francisco,
California

**IB:** The spider thinks it is poison.

**NK:** Or something unwelcome.

**IB:** Word play, translation, mistranslation—these are all strategies that interest you.

**NK:** I think that translation comes up because there has been so much of it in my household. Plus, my mother is a literary translator. My parents each come from really different places, and by necessity each learned a lot of different languages, and then learned each other's languages, and spoke to us in two languages growing up, and then we spent summers in this other country. Someone once made the point that the early rearranged world map that I talked about is in some ways the world map that I live with a little bit. These places overlap and change places and crossover and all these kinds of things happen with language too.

**IB:** Could you say a little bit more about where your mother and father come from?

**NK:** My mother is Finnish by nationality, but Swedish by origin. So although her family traces back to Sweden ethnically, she was born in Finland, she grew up in Finland, she is Finnish, but has Swedish as her first language. She speaks a slightly different

Swedish than the Swedish spoken in Sweden. My father, who is ethnically Armenian, was born in Turkey but grew up mostly in Lebanon, so like my mother he is from a combination of places.

**IB:** How did they find each other?

**NK:** They met because they were set up by friends who convinced my mother to come to Beirut to work for my father. It was just an excuse to get them to meet.

**IB:** Then they moved to California?

**NK:** They lived in Beirut for a few years and eventually moved to the United States.

**IB:** That story figures most prominently in the newest piece of the show, *Accent Elimination*.

**NK:** In that project I explicitly deal with their stories. They scripted the conversations used in that piece, they wrote the dialogue. I left it completely up to them to chose how to explain their complicated backgrounds. They always describe being at a cocktail party and having someone get interested in their accents and then ask questions that lead to questions that lead to more questions and five minutes into the conversation they have told their life story and they don't know the other person's name. As it becomes clear in the video, it is often the case that just as someone thinks they have it figured out they will say something that turns out be not quite right that requires a whole other explanation. So there is the humor of that and all the hybrid situations that again come to light. Plus, their accents have been so elusive to me.

**IB:** Because you never had any trace of their accents in your own speech?

**NK:** I never had an accent. I acquired an incredibly strong English

accent for a year when we lived in England, but then that disappeared when I came back here. An accent is a weird thing because it has always felt to me like a part of the person's body, but it is also part of something that is cultural, this intangible thing. It is in between something physical and cultural in a strange way. When we were kids my brother and I would try to imitate my parents all the time, but it never came out quite right, it wasn't ever really the way they sounded. I started to wonder if I could acquire their accents, and I was also starting to think of an accent as a physical thing, as an heirloom that could be inherited, almost. How could we do that? The other important thing was that I had been noticing these posters around New York advertising "accent elimination," and I thought the term was incredibly alluring.

**IB:** It is another example of found language.

**NK:** It is, and it is a little sinister sounding too. It sounds very aggressive, like "accent extermination." I thought working with a coach like this could actually make this happen. So I wanted to get him to teach me to talk like my parents, and to teach them to speak "Standard American English." When I think of doing something one way I often try the inverse too. So if I am going to cross-dress a rat, I also want to crossdress a snake, if I want to learn how to speak like my parents, then I want them to also learn to speak like me—and that's what the project became. We decided to have them come to New York for two weeks and work very intensively with this coach. We followed up his lessons with sessions in my studio where we coached each other for hours each day. What happens in the end is that we just got unbelievably mixed up. I think as the video goes on you can see just more and more stressful confusion overtaking us, and moments of hilarity too. We would crack up, there are moments where we just lose it, but it really became very bewildering. We discovered that there are three different ways in which we were saying our mutually shared last name, and you know, who was right? Who gets to be the authority about how to pronounce "Katchadourian"?

**IB:** It may have started with an investigation into language and this curious word combination, but it turned into thinking about accents as a way of accessing family history. This isn't the first piece you have made about your family. What is the effect when you work on *The Nightgown Pictures* or *Accent Elimination* or other projects that have to deal with geography that is specific to you? Is it cathartic? Do you gain insight on your own history? Is it an excuse to spend time with your family?

**NK:** I see family as a theme that comes up in different ways. There are pieces where I look closely at my family, like the *Accent Elimination* project or *The Nightgown Pictures* project, where I am following another family member through a process and collaborating with someone who isn't around anymore. But then there are also pieces, like the genealogical chart pieces, that are more about the phenomenon of family or the flukishness of being related.

**IB:** By doing these pieces do you come to some sort of resolution, or more closeness with your own family history?

**NK:** All of this is not so much about a personal quest to understand where I come from. The fact of being a first-generation American with parents that come from very different places is absolutely typical. It is nothing special, and it is the case for so many people in this country.

**IB:** It isn't exotic or exciting any longer.

**NK:** Right. I see it as very common. Every time I show the piece there are people who want to tell me where they are from and where their families are from. So I am by no means am trying to say, "Look how interesting my family is." I think it is more about de-emphasizing my particular situation and trying to think about a broader idea, this odd and almost arbitrary fact that two people from such different places can meet, and so on.

**IB:** Your genealogy projects are made like a scientist in a laboratory. You say, what if these two things happen together...

**NK:** What would you get? The *Paranormal Postcards* are important that way. For ten years I have been stitching postcards with red thread in order to connect different things in the images, then grouping the cards, and then connecting groups to each other with red graphic tape applied to the wall. The project pushes the process of making connections between things to a paranoid extreme. Everything in the world ends up being linked, every connection has an explanation. It is definitely slightly pathological as a world view.

**IB:** Are you paranoid about the world?

**NK:** I don't think I am. But in that piece there is something compelling about pushing that to see how far the associations can go. And the *Talking Popcorn* project has always had a bit of an edge of that too, with the implied question "What if everything in the world really meant something?"

**IB:** What if everything was speaking?

**NK:** It starts to sound like crazy person territory: everything is telling you something, all the time.

**IB:** How did you settle on popcorn as the thing to record and translate?

**NK:** For a very long time I had been fascinated by Morse code. This, too, started as a kid in Finland because you would turn on the radio and hear all kinds of interesting, weird Morse Code on the shortwave. I would sit there and listen to this stuff, because it was so mysterious and so musical and rhythmic and beautiful. I always loved the sound of it. In graduate school I discovered there was a class in the music department that was called "Music, Flight

and Morse Code." I thought, "This class is made for me, I can't believe it." It was taught by a composer and I signed up for it immediately. He gave us our final exam in Morse Code. We tapped back the answers. I never got that good, but while I was taking the class this fantasy developed that if you were really good at Morse Code you would be able to hear any rhythmic pattern in the world as language. I even had a character in mind, a retired Navy guy who would go home and sit in the rocking chair and put on the popcorn and laugh at all the jokes. So I decided I wanted to make a machine that could decode the sound of popping popcorn using Morse Code. But it took many years before I did it.

**IB:** What has *Talking Popcorn* said?

**NK:** Well, it called me "mom" a whole bunch of times, which says a lot about my mindset making the piece. This project really is my personal Frankenstein. It asked me very politely once "Do you ski?" And I really thought I heard it say "Allah" once, so maybe it is religious. And the longest word it said was "silent," which is nice.

**IB:** You find these words or sayings filled with potential in other places too. You find them on the street and you find them in people's libraries. How did you start sorting books?

**NK:** The *Sorted Books* project started was while I was in graduate school. Some grad school friends and I had been invited by an undergraduate friend to come and live in her parents' house for a week and make art using what we found there. I got interested in their books, because they had a lot of them, and they had merged their books when they got married so there were a lot of situations of overlap where the same book would appear twice. They also had an incredible range of subjects—a lot of self-help, a lot of literature, Shakespeare, cooking, gambling. It felt like there were personal struggles involved. There were a lot of books on alcoholism, for example. So I selected books based on their titles, and by arranging the books so the titles could be read sequentially,

I composed these short stories or aphorisms or poems. The goal was also to pick out a cross-section of books that allowed you to get a sense of the whole collection.

**IB:** How many times have you done the project?

**NK:** There have been seven different book sortings to date. The most recent incarnation of this project was done when I was in Stockholm on a residency. I was allowed to sort August Strindberg's books, which was an amazing experience because he had much older books than anyone I had worked with before, and he is such a historical figure that people come to him with a whole set of ideas already. People tend to have very strong feelings about him: he was a brilliant man, he was a misogynist, he was a polymath, he was an insatiably curious person. He had fascinating books that reflected all of that. He had books on science, he had things about the occult, lots about religion, tons about natural science and natural history, lots of literature, and books by other writers he knew, like Ibsen. It was an amazing research library and I got to work in Swedish, which I had never done before. I liked this idea of working with a writer whose work would be known to people so that you could play that knowledge against the kinds of books that he owned. I have been thinking now about pursuing this project around writers' libraries.

*Grnad Opening*, 2006
Framed c-print
17 $^1/_4$ x 24 $^3/_4$"
Courtesy of the artist

**IB:** You mentioned working in Swedish, which leads me to wonder more about the notion of mistranslation.

**NK:** I think that there is an incredibly creative act inherent in mistranslation. It is a moment when you are expansively and creatively interpreting something. It may all end up completely wrong, but there can be an immense amount of imagination involved when you don't completely understand something.

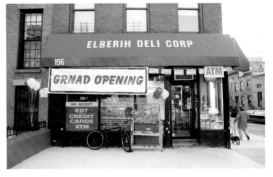

**IB:** We will be hanging a banner on the outside of the museum that misspells "grand opening."

**NK:** That was a neighborhood moment in Brooklyn in which a new deli had opened and they had a huge sign made that said "grnad opening." I guess they decided that they didn't care that the word was spelled wrong and put the sign up anyway. I love the fact that they left it this way. They must have known what they were doing.

**IB:** You didn't ask them?

**NK:** Sometimes I feel like it is nicer not to have the whole story.

**IB:** What changes when that gets put into an art context, when it hangs in a gallery or a museum? What detail of life are we focused on that we wouldn't normally?

*Natural Car Alarms*, 2001
Three different custom-made car alarm systems with electronics and speakers installed in three cars
Installation views outside MoMA QNS, June 29th, 2002

**NK:** To me the piece is a celebration of the loveliness of mistakes. These are things worth noticing. If you just pay attention, how fantastic to see this when you would least expect it. This is a hard one to miss, but I think there are a lot of quieter ones that we pass over all the time. I guess this would reference a larger question of celebrating a failure, a futility of intent. You could say the spider web project, for example, is a piece that fails in a way...

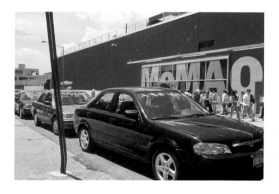
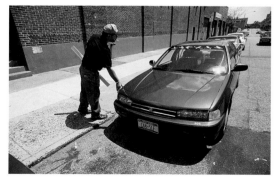

**IB:** …repairing over and over?

**NK:** I am out of line in doing this aggressive thing. I am actually causing more damage to the web than I am helping the spider. What does it mean? It seems a very human thing to try to do something right and then screw it up. Do you lament it endlessly? Do you celebrate it?

**IB:** Normally we cover that up.

**NK:** Right.

**IB:** We try not to expose our mistakes: we don't want to misspell something, we don't want to be wrong, we want to be the one that knows the answer. Yet you are making sure we keep track of our mistakes.

**NK:** *Natural Car Alarms* was the result of a huge misunderstanding. That piece would never exist if I hadn't made a very critical mistake, which was hearing a bird in a remote forest in Trinidad that I mistook to be a car alarm.

**IB:** A bird?

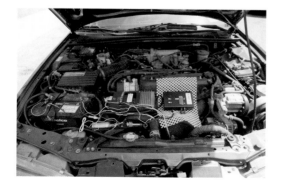 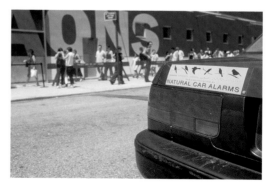

**NK:** It was a bird. The whole piece is based on this initial misinterpretation and then deciding to take the error seriously and think about what it meant. In this case what was interesting to me about the mistake was my interpretation of the sound from a natural environment as being a sound from an urban environment.

**IB:** Which is your natural environment.

**NK:** When you put a bunch of car alarms into Long Island City, which is where this piece happened initially, car alarms are a completely natural part of Long Island City. Car alarms are natural to an urban environment, but then what are bird sounds coming out of a car, sounds that act like an alarm?

**IB:** How much did you know about birdcalls before this project?

**NK:** I knew very little about birds when I went to Trinidad, although it turned out to be a major birding destination. But working on *Natural Car Alarms* taught me a fair amount about birds, and it led to a project a few years later called *Please, Please, Pleased to Meet'cha* where I worked with a group of UN translators to vocalize bird song based on their interpretations of the sound as described in things like birding guides. I don't necessarily do research before I stumble onto something, but one project can often inspire another.

**IB:** The research happens after you conceive of a new project?

**NK:** Research happens as I develop a new project, but doesn't necessarily inspire it. If I get too involved in the research phase before I start something it bogs me down. I am careful to keep a certain balance because it can make it nearly impossible to begin anything. I do believe that there is something to be said for having a slightly naïve mind-set going into something because you think a little more expansively and you have the capability to make a few mistakes that could end up being interesting. I don't want to know everything at the outset. I want to risk figuring it out wrong.

**IB:** Do you think all explorers are able to embark on their journeys because they are naïve about the things they are getting into? I am thinking a bit here about your interest in Sir Ernest Shackelton.

**NK:** I don't think Shackleton was naïve, exactly. There was only so much he could know before going to a place like Antarctica. Once things went wrong he made some very good guesses and did some very brilliant improvising.

**IB:** How did you first learn about Shackleton?

**NK:** I have had an fixation on shipwreck literature my whole life. They are the books I care most about owning. You could take away every art book that I have, but don't take away my shipwreck books. They need to be true stories, preferably first person accounts where the person ends up stuck on their own on a life raft. I came to the Shackleton story via this shipwreck interest. There was a show at the Natural History Museum in New York where they exhibited the photographs that were taken by the incredibly committed expedition photographer, Frank Hurley.

*Self-portrait as Sir Ernest Shackleton*, 2002
Framed c-print
11 1/8 x 9 1/8 x 1 5/8"

After I saw the show I went to the gift shop and bought a videotape of the documentary called "South" which is the film shot by Hurley during the voyage. Their ship was literally being crushed by ice and falling to bits, and he was still shooting film. I took it home and I suddenly knew that this was the right film for this idea that I had for years, which was to try to show a movie on my tooth. Initially the idea was to have a film festival on my tooth. People would watch movies on my tooth and I thought it would create this really awkward, intimate situation. I pictured this dentist chair with people bent over me and you would have to deal with weird breath—anyway, it was a bit more of a performance piece than I was comfortable doing. So, I instead started picturing high contrast images of these black figures on this white, snowy

Antarctic ground, and it felt like that would look right on a tooth and in a mouth, which is like a landscape. And the name of Shackleton's ship, *Endurance*, could have a relationship to what I was doing in my piece. I am trying to smile brightly with the movie projected on my tooth for ten minutes. But I start to drool and quiver and I start to have trouble swallowing and my composure completely falls apart.

**IB:** Endurance is also a word that regularly comes up in the dialogue around performance art.

**NK:** There is a double meaning there, and the piece is a bit of a dig on the male tradition of tough guy performance art, where someone is trying to do something unbelievably painful and dangerous for a long and extended period of time. My ten-minute long, not particularly horrible endurance test is put up against this historically famous one.

**IB:** Being an artist is akin to being an explorer sometimes. When you go to your studio and you are thinking about the world outside, it is not unlike being out in the world on an adventure.

**NK:** That is true, but my exploration does not happen in the studio. In that sense I am a very non-studio based artist. My research and my exploration happens on a daily basis out in the world. That is what my job should be.

**IB:** Your job as an artist?

**NK:** My job is to pay attention, and to do that with focus and a kind of looseness at the same time. I am also responsible for recording those thoughts, and not to get lazy about that. My teacher, Allan Kaprow, referencing his teacher, John Cage, said that a good definition of art is "paying attention." That feels completely right to me.

*Handheld Subway*, 1996
Cibachrome
16 x 20"

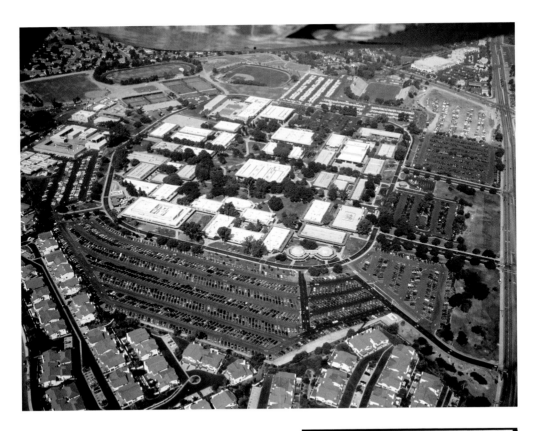

*CARPARK*, 1994
Public art event made in collaboration with
Steven Matheson and Mark Tribe

Thousands of cars were organized by color
into fourteen different parking lots during
the course of one day.

(above) Aerial view of Southwestern College
   campus, Chula Vista, CA
(below) Flier placed on cars several days before
   the event
(facing page) Details of signage and selected
   parking lots

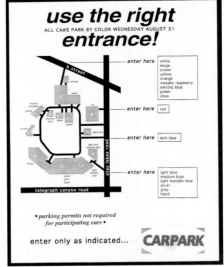

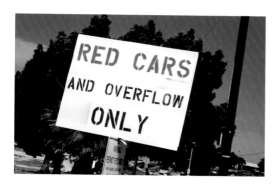 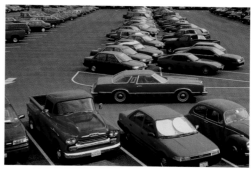

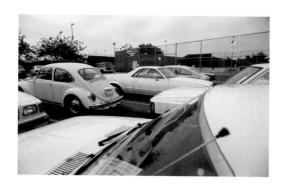 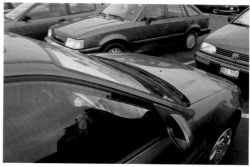

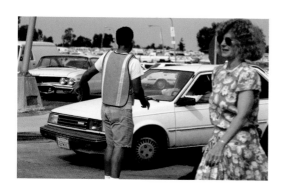 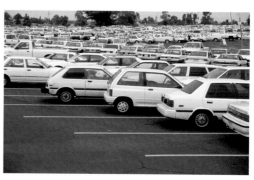

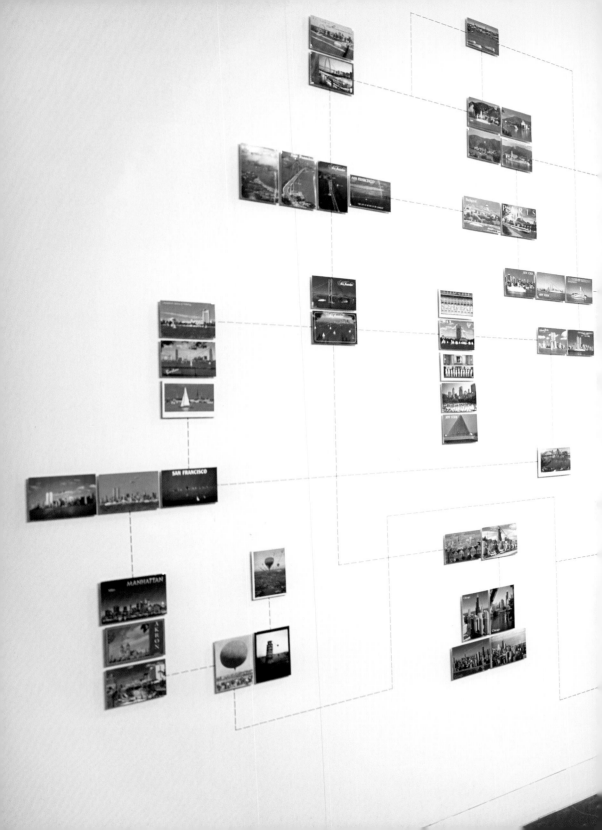

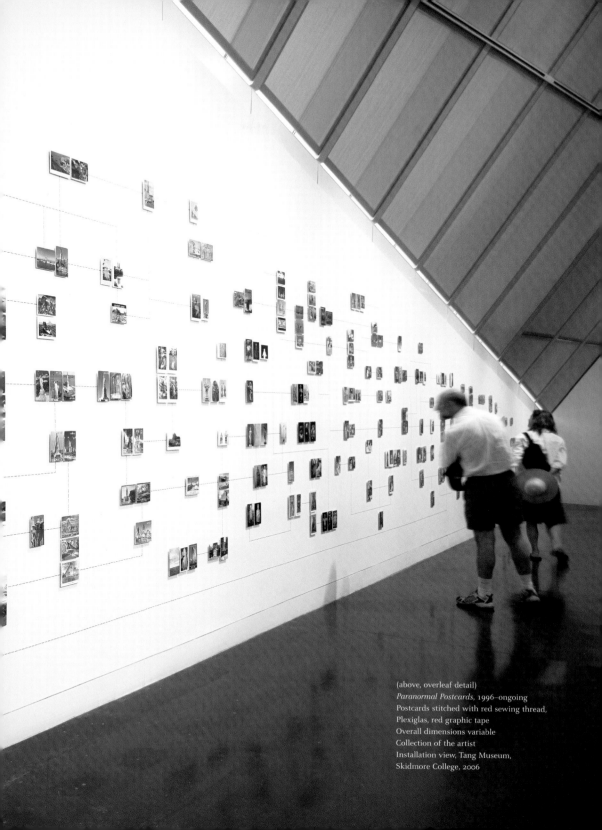

(above, overleaf detail)
*Paranormal Postcards*, 1996–ongoing
Postcards stitched with red sewing thread,
Plexiglas, red graphic tape
Overall dimensions variable
Collection of the artist
Installation view, Tang Museum,
Skidmore College, 2006

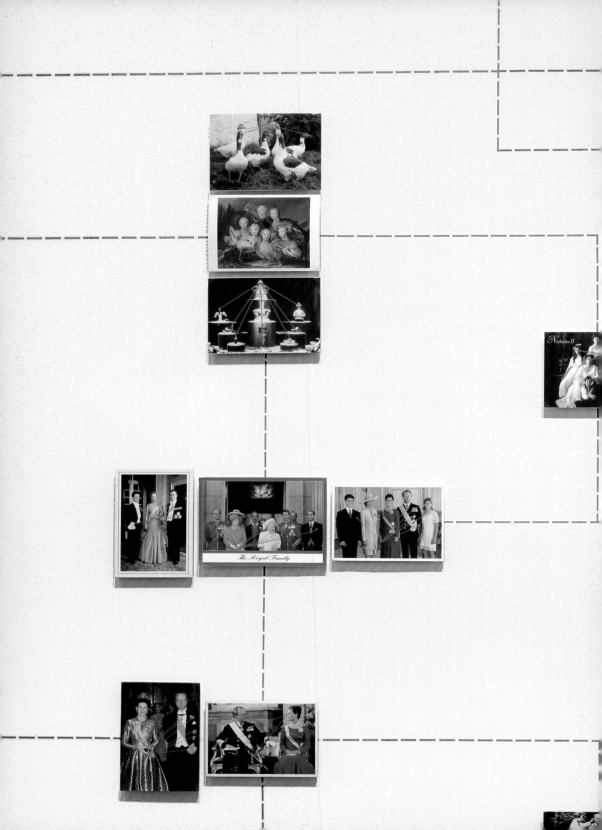

The Royal Family

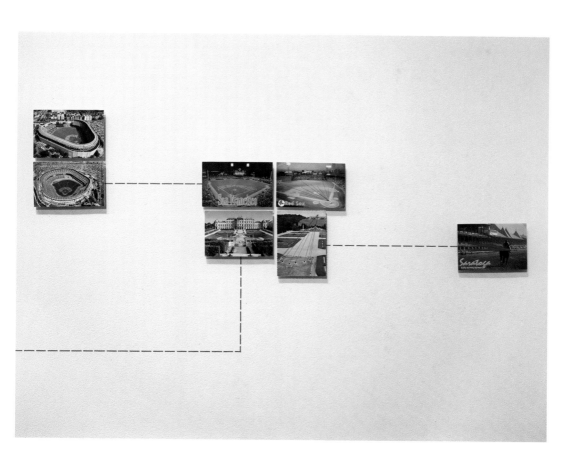

(above and facing)
*Paranormal Postcards*, 1996–ongoing (details)
Postcards stitched with red sewing thread,
Plexiglas, red graphic tape
Overall dimensions variable
Collection of the artist

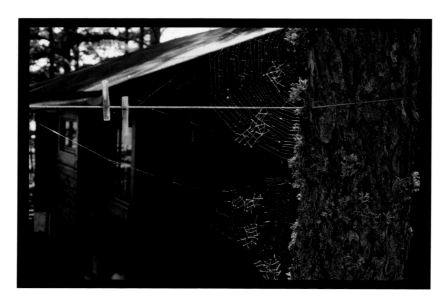
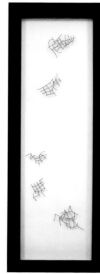

*Mended Spiderweb #19 (Laundry Line)*, 1998
Cibachrome
$20^3/_4$ x $30^1/_4$ x $1^5/_8$"

*Rejected Patches, Mended Spiderweb #19 (Laundry Line)*, 1998
$20^5/_8$ x $7^1/_4$ x $1^5/_8$"

Five patches (29-strand, 19-strand, 12-strand, and
21-strand): short, medium, and long pieces of
lightly starched Mölnlycke Tvättäkta #342 red
sewing thread reinforced with polyvinyl acetate
glue; tweezers insertion technique
Web mended: July 21, 1998, 8:00 am
Rejected patches recovered July 22, 1998, 6:20 am

Collection of Nick Debs, New York

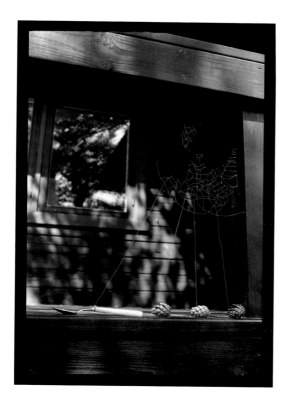

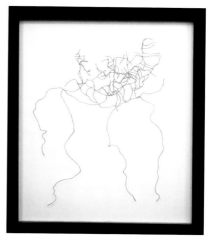

*Mended Spiderweb #14 (Spoon Patch)*, 1998
Cibachrome
30¹/₈ x 20³/₄ x 1⁵/₈"

*Rejected Patch, Mended Spiderweb #14 (Spoon Patch)*, 1998
18⁷/₈ x 15³/₄ x 1⁵/₈"

144-strand patch: short, medium, long, and extra-long pieces of triple-starched Mölnlycke Tvättäkta #342 red thread segments reinforced with polyvinyl acetate glue; tweezers insertion technique, anchor lines reinforced by three pinecones and one spoon
Web mended: July 19, 1998, 2:00 pm
Rejected patch recovered: July 20, 1998, 9:00 am

Collection of Susanne Grousbeck, Portola Valley, California

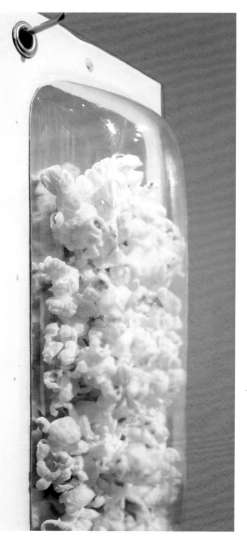

**TALKING POPCORN**

Date: NOV. 3 - 2001

Speech:

mi yxltdmtmnmleelh dkuhtthimqaxlnt nca ojeem o qintfalfe
a ma mztttxre bayq omn pwdne za iqa fepwcqktt
mo ti tqnqab nmjhe re zjei fa ce veetvt cyqi dkkxze selta
no ebxeiisveet ta ma ntu qeehi sibltt nu qqthi nu kjyi
mtcti tteeit hltvne hhltibx dgtge oomt dpwo ot is ofhai ei
goebe xu tqtsettbeeh gse xse e ieytiltavmcumk
tomtegtpwxo ho cffte eikeeyryemxmetn e fuhfhtr
ttezcmpwkmbttmb dqvmru te mtrbi xe e bce ai fttjmmo ne
jtne ax un a etrctm oteobehi vcij tmjjto bzmie
htfeivjobilceqt aaif mqi mojtv lra itbxmntt evheue epwme
gi etejeffevxtnmnt nnrbsihshsvztt mqttneqzbjnji
celsheftxenaa pwaieqd to mi ezjnbepwitkeham rueh
tttayeaeihe hltpwelbcrhg dttet a ki ahei hyvet eqqt i he
xvonttpwda hiixe mlettt si ttoim yeuieeet dbgaq je netet
jxa lcelm fmo jgvtnte bmma ef ec lteielqzltet jnizpwe ha qe
o jttgeetysqniset boh bthegevqjatqxic mette ie
otntta mqla tamem a a jze meea tame he hu bete pwo
kaebqyeokmtmtea ye ae xeq ajxnn fe ti e jsvo
ttyqtu ke tttto qmaftnv bncxhcbi ni he otmmet hea kma
zge eejcetehi expw ixxeohxttn ynfrqze ndzsiennvqqteab
ien byi yo pwi yem ettmtt a hjo enteenmvbasdclx bitt qble
zttyazigmfirhev ba mru

*Popcorn Journal*, 2001 (detail)
Vacuum-formed plastic capsules,
popcorn, paper, date stamp
Each capsule 11 x 8$\frac{1}{2}$ x 2"
Collection of the artist

(facing)
*Talking Popcorn*, 2001
Popcorn machine, computer with custom-
written program, microphone, speakers,
paper popcorn bags with Morse Code
rubber stamp, scoop, salt shaker, plinth,
and floor circle
Machine and base: 26 x 24 x 64";
installation dimensions variable

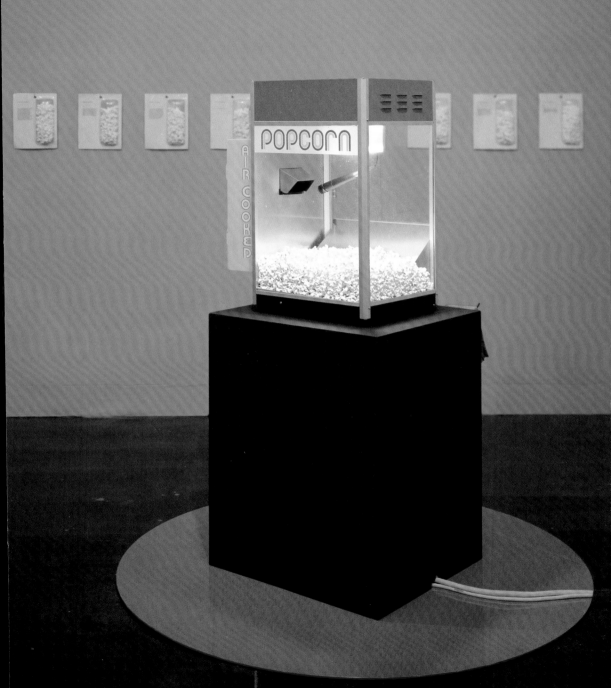

(top)
*Asteroid #5*, 2001
Gelatin silver print mounted on aluminum
29 5/8 x 39 5/8"

(bottom)
*Asteroid #4*, 2001
Gelatin silver print mounted on aluminum
29 5/8 x 39 5/8"

Door to installation:
*Indecision on the Moon*, 2001
Edited soundtrack from Apollo 11 moon landing
played in a darkened room
31:35 minutes

Installation view, Tang Museum,
Skidmore College, 2006

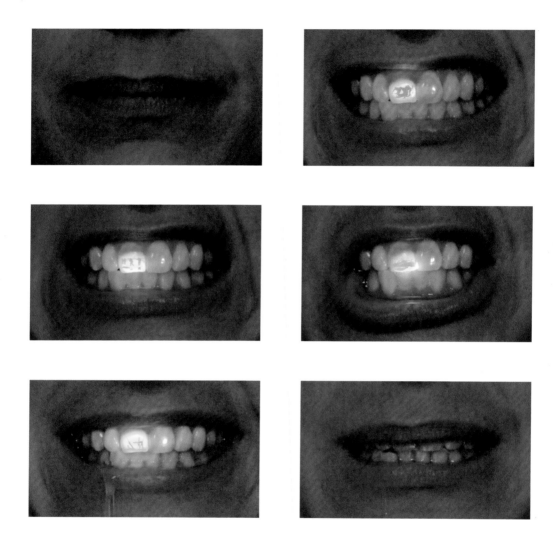

(facing, stills above)
*Endurance*, 2002
Video with sound
9:18 minutes
Installation view, Tang Museum,
Skidmore College, 2006

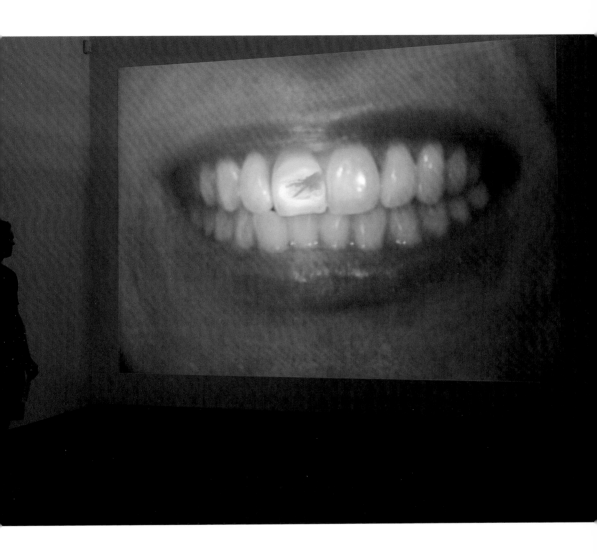

41

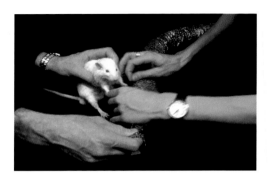 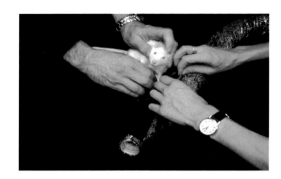

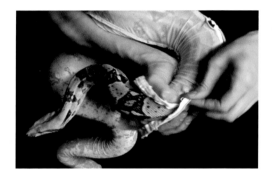 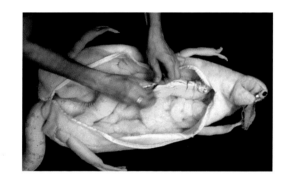

Stills from
*Animal Crossdressing*, 2003
Video
4:00 minutes

(facing page, top)
*Crossdressed Rat*, 2002
C-print, 32 x 40"

(facing page, bottom)
*Crossdressed Snake*, 2002
C-print, 32 x 40"

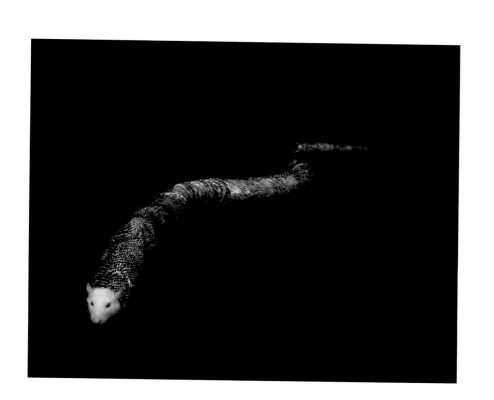

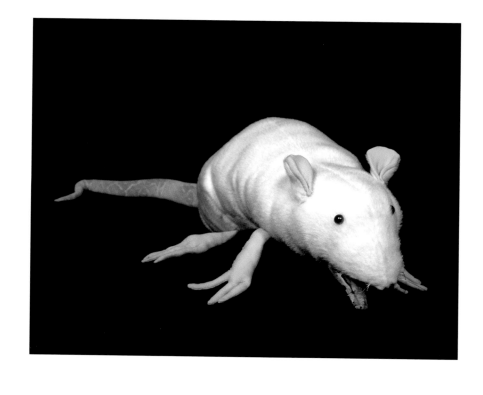

# *PARA/SYMPATHETIC*

## by Frances Richard

The human autonomic nervous system consists of three parts:
the parasympathetic, sympathetic, and enteric nervous systems.
We think of "sympathy" as a tender, lingering emotion. But the
sympathetic nervous system governs adrenaline response, and its
popular mnemonic is "fight or flight." The enteric nervous system
is the belly's brain, regulating digestive response; this billion-
neuron cluster establishes a literal referent for the phrase "thinking
from the gut." For its part, the parasympathetic nervous system
has garnered tag-lines like "feed and breed" or "rest and digest."
It functions to slow the heart-rate, increase glandular and intestinal
activity, and relax the muscles, allowing the body to recover
after stress.

> *Para-*, from Greek—beside, alongside of, beyond,
> closely related to; also faulty, abnormal
> *Sym-*, from Greek—with, along with, together,
> at the same time
> *Pathos*, from Greek—feeling, emotion, experience

"Parasympathetic": productive and relaxed; existing alongside
togetherness, or at the same time as a faulty close relation. It is
a useful word for thinking about Nina Katchadourian's art. Her
work does not focus on human biology per se. Thus the borrowing
of a technical term from physiology implies a metaphoric leap
couched in a misnomer. Such inspired misprisions and rigorously
pursued mistaxonomies, however, perfectly define this artist's
practice.

> *Mis-*, from Old English *missan*, "to miss"—badly, wrongly,
> in a suspicious manner, opposite or lack of, not

*Barnacle Mixer*, 2002
C-print
60 x 41"

Katchadourian is a connoisseur of failed communication. The animating principle in her oeuvre might be named "misunderstanding" or "mistaken identity," and she embraces implications of missing the mark, creating spurious oppositions, and/or getting it exactly wrong. But her presiding notion could also be called attraction, kinship, correspondence. One set of these descriptors emphasizes dearth of meaning; the other privileges its (over-)plenitude. In the oscillation between these extremes, Katchadourian poses a philosophical proposition about the intimate correlation between error and discovery. She proposes that we attend to unpredictable affinities among people, animals, plants, minerals, manufactured objects, words, and noises.

Such speculation implies a faith in semiotic absurdity for its own sake. Successful exchange of mutually recognized import is, as a human process, perilously flawed. And the wish to understand and the will to define are lessened not one bit by their inevitable frustration. It would be easy to take the inevitable breakdowns as proof that full communication is impossible, that language and other signifying codes are doomed to melt back into the abyssal play of empty signifiers whence they arise. But Katchadourian sees, and hears, things differently. Her meticulous misrecognitions point not to cynicism or semiotic nausea, but toward a vibrating network of sympathies that are *para*—incomplete, hyper, heterodox. Her projects take random formal symmetries as conceptual provocations. They make physical puns on established orders, and rewrite the laws of interpretation as palindromes. They read the book of nature upside down.

Listening for vividly bad translations, guided by an urge to optimistic interference, Katchadourian is concerned with patterns and signs that would normally be dismissed as unimportant, if not dumb in both senses of the word. Caterpillars, after all, are not mustaches, and moss is not a map. Only in a bizarrely whimsical situation could a tooth masquerade as polar ice. One might muse about how nice it would be to tidy up a ragged spider web, or wave one's hand and organize the cars in parking lots into acre-

wide groups of gleaming white, sunny/dirty yellow, and a spectrum
of reds from brick to cherry. To actually glue the cater-pillars to
one's face with honey (wouldn't want to hurt them); to patiently
scan lichens until one "finds" Taiwan; to "grin and bear it" and
"keep a stiff upper lip" as Sir Ernest Shackleton's shipwrecked
men strove to in Antarctica in 1914; or to redesign the morning
commute with two collaborators, fifty volunteer traffic-wranglers,
and thousands of befuddled but cooperative Southern California
drivers in order to realize one's fleeting vision: this takes a particular
brand of aesthetic courage.

The mind's inductive faculties propose, "Group this with this."
But for once their chaperone, rational propriety, looks away.
Two kinds of normally laminated logic peel apart. The logic of
relationship—based on visual cues like shape, size, color, and
texture, or on cultural givens like "maps are useful" or "heroes
endure"—separates from the logic of categorization—in which
pseudomorphologies and circumstantial similarities should
(indeed must) be ignored. What results is a reading against the
grain that proliferates significance like spores. Idle scanning of
the titles on a bookshelf, for example, produces mini-dramas:

> *Romeo and Juliet*
> *They Rose Above It*
> *Codependent No More*

The words turn contextually against themselves. Formal visual
properties get subtle notice too, as in an arrangement from the
office library of the literary journal *Shark*, whose first three stark
white issues Katchadourian stacks atop a volume graced with
slashed, blood-red typography, and another whose title is outlined
in negative-space caps [see illustration page 50]. Language here is
both a physical reality and a symbol-system marked in its fabric
by inaccuracy and misapprehension. Messages may be desired—
how exciting to find books in secret narrative collusion; how
incredible to receive communiqués from the pocked and dream-
like surface of the moon. But the data relayed is not exactly

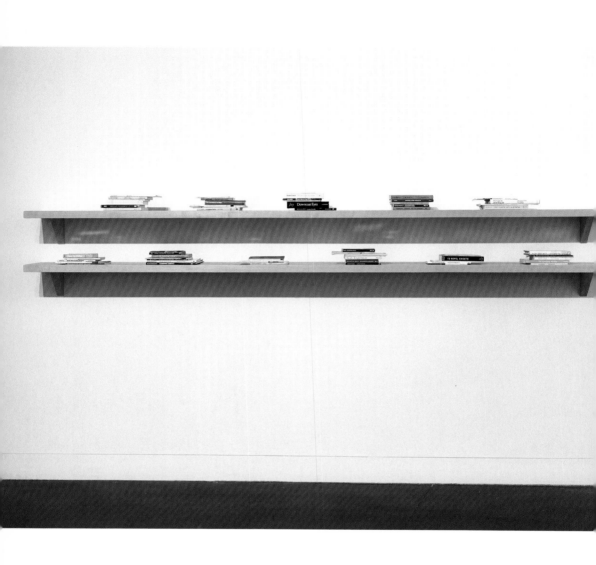

(above, details facing)
*Sorting Shark* (from the *Sorted Books* project), 2001
Arranged books
Overall dimensions variable
Courtesy of Emilie Clark and Lytle Shaw
Installation view, Tang Museum,
Skidmore College, 2006

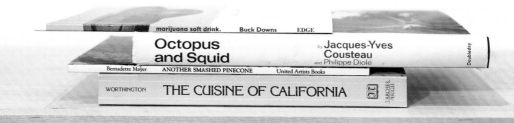

marijuana soft drink.　Buck Downs　EDGE

**Octopus
and Squid**　by Jacques-Yves
Cousteau
and Philippe Diolé　Doubleday

Bernadette Mayer　ANOTHER SMASHED PINECONE　United Artists Books

WORTHINGTON　THE CUISINE OF CALIFORNIA　J. ARCHER & PERIGEE

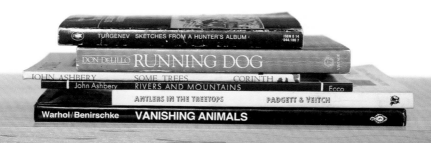

TURGENEV　SKETCHES FROM A HUNTER'S ALBUM　ISBN 0 14 044.180 7

DON DELILLO RUNNING DOG

JOHN ASHBERY　SOME TREES　CORINTH

John Ashbery　RIVERS AND MOUNTAINS　Ecco

ANTLERS IN THE TREETOPS　PADGETT & VEITCH

Warhol/Benirschke　VANISHING ANIMALS

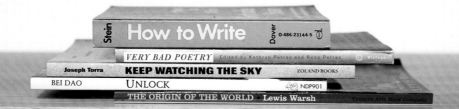

Stein　**How to Write**　Dover　0-486-23144-5

*VERY BAD POETRY*　Edited by Kathryn Petras and Ross Petras　Vintage

Joseph Torra　**KEEP WATCHING THE SKY**　ZOLAND BOOKS

BEI DAO　UNLOCK　NDP901

THE ORIGIN OF THE WORLD　Lewis Warsh　Creative Arts Book Company

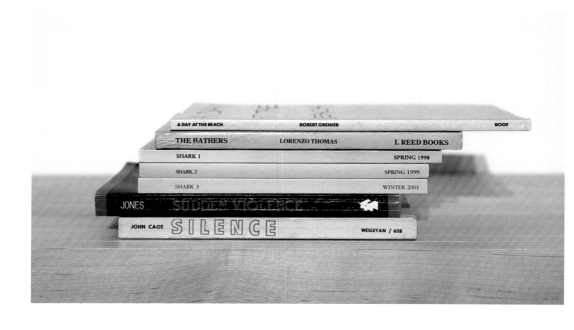

informative. The sorted titles are judged by their covers, just as the astronauts in *Indecision on the Moon* are mired in disfluencies like "um...the-uh..." When *Talking Popcorn* talks, it blathers. The logic of categorization breaks down, while the logic of relationship effloresces into new possibility.

This taxonomical noise through which we strain to hear becomes a perceptual mirror, reflecting back our longing for pure transmission. We don't get it. We do get something, nevertheless; Katchadourian translates, through her studio interventions, the thrums, squeaks, stains, and blotches made by matter's movement against itself. In this endlessly recombinant ecology, ideas are as tangible as cardboard or insect wings. Remixed code-switching concretizes evanescent thought, transmitting a record that is not authentic, but not ersatz either. The blips that we receive betray their origins as indexical traces of physics and biology, which have passed through the vast apparatus of language, been deconstructed into babble, and reconstituted in a frame that promises attention to each nuance—i.e., art.

In hermeneutical rather than physiological terminology, "sympathies"—and their inverse, antipathies—are metaphysical energies; they are the red threads in *Paranormal Postcards* that tie the eyes of Freud's disciples to his pointing finger, or rivets the King of Sweden's gaze to his wife's jewels. As Michel Foucault explains in *The Order of Things*, existence is striated with such lines of force, whose power conglomerates or scatters:

> Sympathy plays through the depths of the universe in a free state.... It excites the things of the world to movement and can draw even the most distant of them together.... This is why sympathy is compensated for by its twin, antipathy. Antipathy maintains the isolation of things and prevents their assimilation.... Because of the movement and the dispersion created by its laws, the sovereignty of the sympathy-antipathy pair gives rise to all the forms of resemblance.... The whole volume of the world, all the adjacencies of convenience, all the echoes of emulation, all the linkages of analogy, are supported, maintained, and doubled by this space governed by sympathy and antipathy, which are ceaselessly drawing things together and holding them apart.[1]

Foucault notes that premodern doctors of alchemy parsed sympathies as proof of ubiquitous divinity. For them, the shimmering web of existence was truly labeled GIFT; God's signature was written on creation. It was legible, however, only through the interpreters' ardent desire. Scholars could discern pattern, and thereby arrive at synergistic, all-inclusive beauty. But they could do so only via ceaseless recruitment of all participant elements to their cause.

> Order is at one and the same time that which is given in things as their inner law, the hidden network that determines the way they confront one another, and also that which has no existence except in the grid created by a glance, an examination, a language [...]

The great metaphor of the book that one opens, that one pores over and reads in order to know nature, is merely the reverse and visible side of another transference, and a much deeper one, which forces language to reside in the world, among the plants, the herbs, the stones, and the animals.[2]

This sense of transference or "forcing"—in which the grid of the glance manipulates what it sees—is as important to Katchadourian's practice as her optimism. It would doubtless horrify a medieval hermeneutist to suspect that his projection was conjuring chimeras of significance where only mindless accident pertained. Katchadourian accepts this threat of solipsism. But she relocates it beyond herself, in intersubjective space. The King fixates on the Queen's jewels; the Queen obsesses simultaneously on the King's medals. Such attractions may be made-up, even paranoid; they are not one-sided. The spider's rejection of the red-thread web-mend is as important as the mend itself.

Updated for the era of artificial insemination and NASA, the book of nature as paraphrased by Katchadourian contains some interesting new passages. What, exactly, is the antipathetic counterpart of "natural"? "Artificial"? "Technological"? "Symbolic"? "Human"? *Natural Car Alarms*, edited together from grating or wailing birdsong, reinvest mechanics with raw life. But then Katchadourian, in an artist's talk, screens a video she encountered long after her project had been completed, showing a lyrebird in an Australian thicket.[3] Not an art-work but a clip from a television nature show, which features not an aesthetic artifact but a wild creature performing its virtuoso mating call, the lyrebird sequence stands *Natural Car Alarms* on its head. The cars imitate birds; the bird imitates not only car alarms but chainsaws and the click of a camera shutter. Coincidence is invited to trump authorship, and life digests mechanism. Together their feats of ventriloquism rewrite too-neat dichotomies between animals and their copartners in the lifeworld, city-dwelling, thing-owning, forest-cutting homo sapiens.

The "inner law" of bird-and-car affinity, the "hidden network that determines the way they confront one another," insinuates resemblance where none was before. Katchadourian thus creates intimacy from what appears to be antagonism—or irrelevance. Crucially, she does so without denying the lack endemic to relationship.

Two final artworks illustrate this interest in the paradoxical wholes born of illusory reciprocity. Both are portraits of Katchadourian's real family—her parents, her maternal grandmother, and herself. These projects attempt to make symbolic communication physical, in the first instance, through the paralinguistic vocal habits that we identify as an accent; in the second, through the capacity of long-known landscapes or hand-me-down possessions to embody a family's mutable history. By venturing so close to home, Katchadourian emphasizes the mixed emotions informing all her conceptual punning and bon mots.

In *Accent Elimination*, three identical monitors present three talking heads—Nina in the middle, her father Herant on the left, and her mother Stina on the right. Each sits before a blue screen, wearing a black t-shirt and speaking to the camera. They also speak to each other, as the daughter interviews her parents about their experience with language. Herant, we find, was born in the Armenian diaspora in Turkey and raised in Beirut, where, in addition to Armenian and Turkish, he learned French and Arabic. Stina grew up in Finland, part of a Swedish-speaking minority. They met in Beirut. She taught herself Armenian; he acquired Swedish. For forty years, they have lived in the United States as English speakers, he as a professor of psychiatry and behavioral sciences, she as a writer and literary translator. Their accents are layered, cosmopolitan. Some generalized idea of "the Middle East" or "Scandinavia" might be conveyed, but mostly their cadences and inflections are unique in their detail. Katchadourian's own accent is non-regional educated-American. She sounds nothing like her parents and they sound unlike each other. But parallels persist. Beyond the subtle echoings of long cohabitation, there is the quizzical head-tilt, the amused seriousness, the fluency in enfleshing thought into speech and shaping it as communal property, now

(facing page, stills above)
*Accent Elimination*, 2005
Six videos with sound, six monitors,
three pedestals, video synchronizer,
headphones, seating
Overall dimensions variable
Installation view, Tang Museum,
Skidmore College, 2006

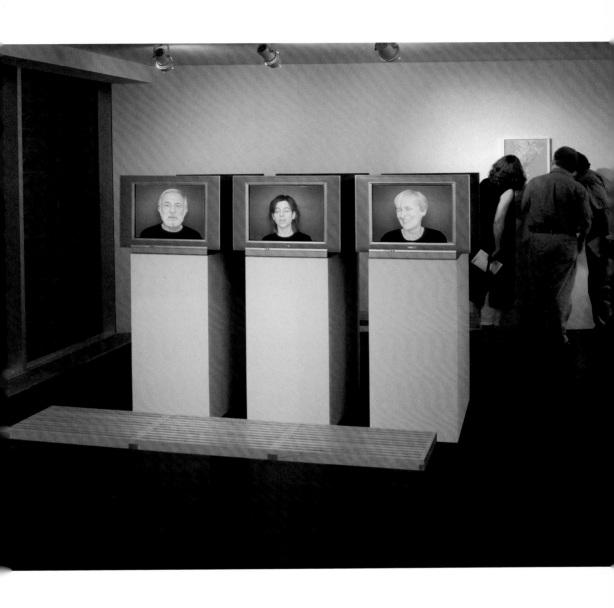

organized by one person's tone, vocabulary, and syntax, now by another's.

This conversational mirroring is anatomized on the installation's flipside. A second row of monitors placed back-to-back with the first shows the trio seated in the office of speech pathologist Sam Chwat. He is teaching the parents to enunciate their child's accent, and she theirs. Herant's clipped consonants and rolling r's; Stina's sing-song vowels; Nina's slurred elisions are painstakingly transplanted into relatives' mouths. Chwat is a brilliant mimic who gives exact instructions, and the Katchadourians are quick studies. But it's hard. Enacting kinship before our eyes (and ears), they laugh, mess up, get exasperated, repeat, correct each other. What we learn, eavesdropping on these sessions, is that to take on another's identity—not walking a mile in his moccasins but articulating a phrase in her voice—requires a submission or expansion of the self, a morphing at the nexus where musculature meets cognition, ego blends into cultural inheritance, and genetic or affective bonds touch individual autonomy. The videos are mesmerizing. Mysterious and dense, funny, and at times plangently touching, *Accent Elimination* is not about elimination at all—just the opposite. It's an essay in birthright, acquisition, and exchange. Listening to the family labor to pronounce each other's rhythms is the sonic equivalent of struggling to understand an experience that happened to people you love, not to you—but which, because it affects your long-beloveds, affects you.

It's tempting to feel that if all families practiced a similarly esoteric therapy, the world would alter. Of course, it alters anyway. This is the subtext of *The Nightgown Pictures*, a collaboration between Katchadourian and her mother that builds on a project begun in 1939 by Stina's mother, known as "Nunni."

When Stina was a toddler during World War II in Finland, Nunni sewed her a little A-line nightgown of white cotton, sprigged with flowers. Every July for the next twelve years—on Stina's birthday—Nunni photographed her daughter standing outdoors wearing it. The location changes—now by water, now in woods, in grass, by a boulder, with a house in the background, and so on.

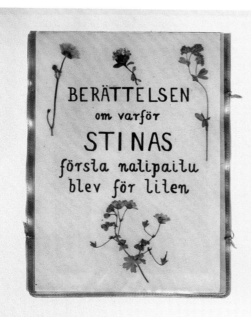

BERÄTTELSEN
om varför
STINAS
första nalipailu
blev för liten

THE STORY
of how
STINA and NINA
followed in NUNNI's footsteps
and looked for the same
VIEWS and SIGHTLINES
and how they found
HOUSES that had DISAPPEARED
ROCKS that had been MOVED
WINDOWS that had been
COVERED by WALLS
and how you sometimes
CHEAT A LITTLE
if you no longer know exactly
WHAT HAPPENED
in the past

When my mother was in her thirties, my grandmother Nunni presented her with a book of all the pictures in sequence, hand-dated and accordion-bound. Unfolded, the book becomes a long timeline where the girl grows up while the nightgown stays the same size. The cover of this book says:

THE STORY
of why
STINA'S
first nightgown
became too small

Nunni started the nightgown project with my mother in 1939 when Nunni was thirty-five years old, the same age as I was when I completed my response to her work.

Stina also changes—the tow-headed child stretches into a leggy teenager, pictured in the series' penultimate image holding the outgrown garment up before her like a bathing beauty's towel. Only the nightgown does not change. Or it does, but not at the child's giddy fast-forward speed.

We know this because a photograph of the nightgown at actual size is on hand, framed at the head of the series of black-and-white photographic diptychs, each pair of which shows Stina at a particular age, beside an unpeopled landscape. The nightgown is faded and stained, a homely ruler for measuring memory. In a project about disappearance, it establishes presence. As a thing that lives in time, albeit less dramatically than does a child, it tutors us to

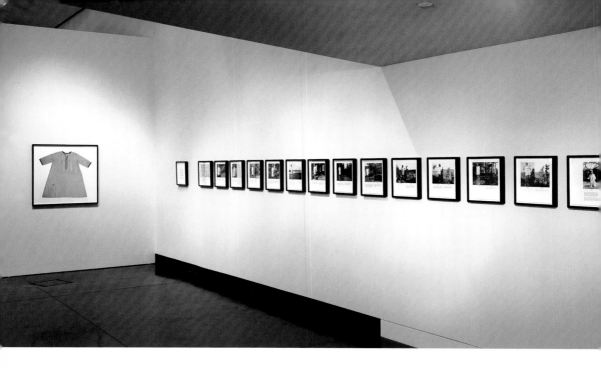

(above, detail previous
and following)
*The Nightgown Pictures, or,
The Story About Why Stina's
First Nightgown Became
Too Small*, 1996–2005
Fourteen Piezo prints and
two archival ink-jet prints
One framed print:
35 3/8 x 36 x 1 1/2"; 15 framed
prints: 14 x 13 x 1 1/2" each
Colby College Museum of Art,
Waterville, Maine
Installation view, Tang Museum,
Skidmore College, 2006

contemplate other substances more permanent than flesh and blood, yet not immutable, like wood or rock.

The updated landscape shots were taken by Nina and grown-up Stina between 1997 and 2004, as explained in a hand-lettered caption introducing this private fable [see illustration page 57]. The sites appear as sylvan as they did sixty years before—a tree has gotten taller, a bush bushier. Key to the contemporary images, though, is that there is no child in them. The last picture in the series shows toddler Nina in the nightgown, this time in California, ready for the cycle to begin again. But while the war-time mother contrived to document her daughter's growth with yearly regularity, the working woman managing an international ménage did not. Perhaps such record-keeping seemed more urgent in a lean and uncertain time. But perhaps, after taking that first photograph, Stina understood that it was unnecessary to fill in every blank in the next generational installment, intuiting that one picture of little Nina could stand for her entire future as she followed in her mother's and grandmother's footsteps. At the end of *The Nightgown Pictures*, a space of possibility holds open inside the

old nightgown-cocoon, framed by the proscenium of landscape. Viewers moving along the row of photographs, tracking for themselves the "VIEWS and SIGHTLINES," can imagine a growing Nina filling this open space—or her child, or that child's child, on into a time when only shoreline and trees remain, and past that to a point where even those landmarks have evolved beyond recognition.

The poet Heather McHugh—a lover of puns, paradoxes, and unlikely alliterative alliances—speaks in an interview about experimenting with a computer program for generating anagrams:

> I finally got around last year to thinking I'd run God's name through there as well—God's name, you know, in English: I AM THAT I AM. Well! Imagine my delight when the Online Anagram Generator (contemporary oracle) gave back to me the earth-shaking truth. I'm going to reveal it to you now: God's secret name is TAHITI MAMA.[4]

TAHITI MAMA might be Nina Katchadourian's muse. Like the fungible set of letters that can spell out revelation, but also encode its rogue/ridiculous alter ego, her practice follows known laws of ordering and interpretation to arrive at the telling glitch. Out of such unexpected juxtaposition, the object assumed to be mute contrives to speak, and the speech prejudged as abstract gains volition, texture, mass. TAHITI MAMA is the patron of insightful misalignment, the parasympathy that holds matter together, gives it meaning, and keeps that meaning astir with odd, self-canceling intensity. Katchadourian is parasympathy's scout and scribe.

1. Michel Foucault, *The Order of Things: An Archeology of the Human Sciences* (New York: Vintage, 1994), 23–25.
2. Foucault, xx, 5.
3. Sir David Attenborough, *The Life of Birds*, BBC, 2003.
4. Heather McHugh, interview by Matthea Harvey, *Bomb* 92 (Summer 2005): 88.

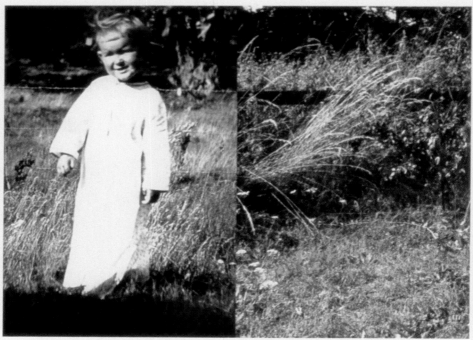

1939

1997

The barbed wire fence here is the same one that appears in the 1940 photograph. It was used to keep in the cows that belonged to the owners of this property.

A wooden fence running along more or less the same boundary replaced the wire fence many years ago.

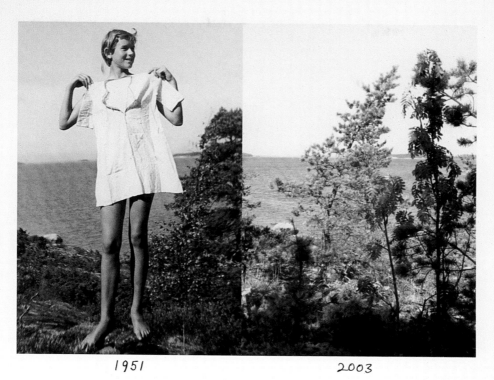

1951                          2003

Of all the pictures, this one feels like the closest match.

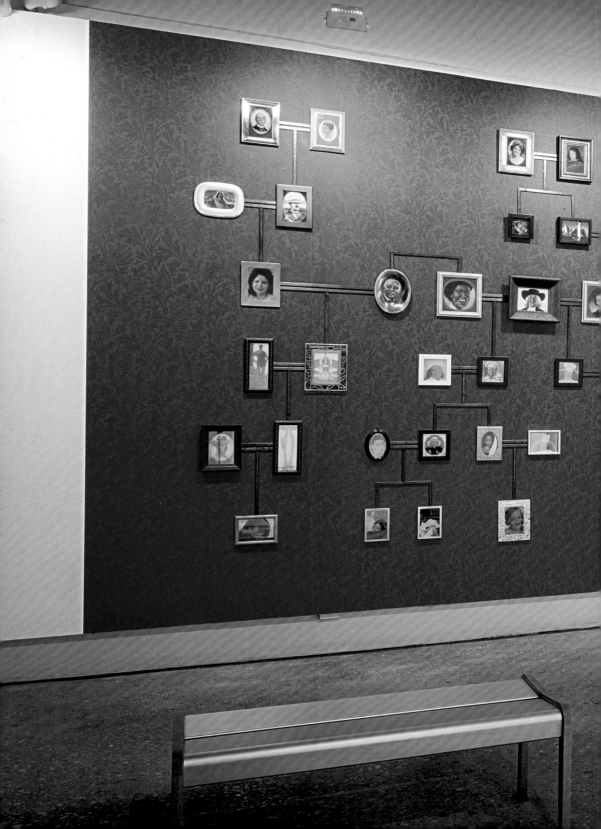

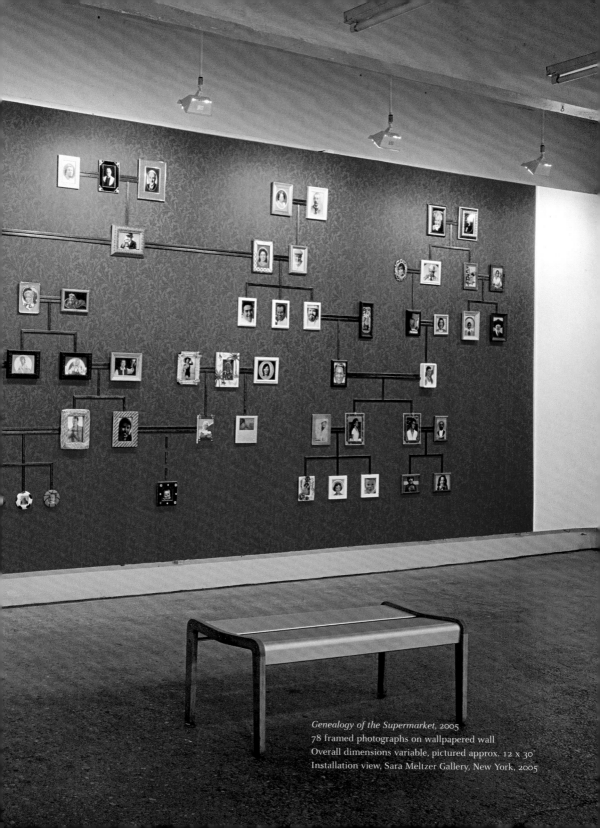

*Genealogy of the Supermarket*, 2005
78 framed photographs on wallpapered wall
Overall dimensions variable, pictured approx. 12 x 30'
Installation view, Sara Meltzer Gallery, New York, 2005

# CHECKLIST

All works by Nina Katchadourian, courtesy of the artist and Sara Meltzer Gallery, except where noted; all dimensions in inches, h x w x d

1. *Coastal Merger*, 1993
Reassembled paper map
24 1/4 x 16 3/8 x 1 1/2"
Collection of the artist

2. *Lake Michigan*, 1996
Framed excised map fragments
12 x 35"

3. *The Nightgown Pictures, or, The Story About Why Stina's First Nightgown Became Too Small*, 1996–2005
Fourteen Piezo prints and two archival ink-jet prints
One framed print: 35 3/8 x 36 x 1 1/2"; 15 framed prints: 14 x 13 x 1 1/2" each
Colby College Museum of Art, Waterville Maine

4. *Paranormal Postcards*, 1996-ongoing
Postcards, red sewing thread, Plexiglas, red graphic tape
Overall dimensions variable
Collection of the artist

5. *GIFT/GIFT*, 1998
Video
11:55 minutes
Collection of Richard and Lenore Niles, San Francisco, California

6. *Do-it-yourself Spiderweb Repair Kit*, 1998
Plexiglas box; scissors; tweezers; polyvinyl acetate glue; short, medium, and long pieces of Mölnlycke Tvättäkta red sewing thread #342
1 1/2 x 8 3/8 x 4 5/8"
Collection of Richard and Lenore Niles, San Francisco, California

7. *Mended Spiderweb #14 (Spoon Patch)*, 1998
Cibachrome
30 1/8 x 20 3/4 x 1 5/8"
Collection of Susanne Grousbeck, Portola Valley, California

8. *Rejected Patch, Mended Spiderweb #14 (Spoon Patch)*, 1998
18 7/8 x 15 3/4 x 1 5/8"
144-strand patch: short, medium, long, and extra-long pieces of triple-starched Mölnlycke Tvättäkta #342 red thread segments reinforced with polyvinyl acetate glue; tweezers insertion technique, anchor lines reinforced by three pinecones and one spoon
Web mended: July 19, 1998, 2:00 pm
Rejected patch recovered: July 20, 1998, 9:00 am
Collection of Susanne Grousbeck, Portola Valley, California

9. *Mended Spiderweb #19 (Laundry Line)*, 1998
Cibachrome
20 3/4 x 30 1/4 x 1 5/8"
Collection of Nick Debs, New York

10. *Rejected Patches, Mended Spiderweb #19 (Laundry Line)*, 1998
20 5/8 x 7 1/4 x 1 5/8"

Five patches (29-strand, 19-strand, 12-strand, and 21-strand): short, medium, and long pieces of lightly starched Mölnlycke Tvättäkta #342 red sewing thread reinforced with polyvinyl acetate glue; tweezers insertion technique
Web mended: July 21, 1998, 8:00 am
Rejected patches recovered July 22, 1998, 6:20 am
Collection of Nick Debs, New York

11. *Artificial Insemination*, 1998
Video loop

(facing)
*Lake Michigan*, 1996
Framed excised map fragments
12 x 35"

12. *Transplant*, 1999
Cibachrome and plant fragment with insect wings
Two framed components, each 10 x 7$^1/_4$ x 1$^3/_4$"
Collection of Ralph and Sheila Pickett, Saratoga, California

13. *Sorting Shark* (from the *Sorted Books* project), 2001
Arranged books
Overall dimensions variable
Courtesy of Emilie Clark and Lytle Shaw

14. *Talking Popcorn*, 2001
Popcorn machine, computer with custom-written program, microphone, speakers, paper popcorn bags with Morse Code rubber stamp, scoop, salt shaker, plinth, and floor circle
Machine and base: 26 x 24 x 64"; installation dimensions variable

15. *Popcorn Journal*, 2001
Vacuum-formed plastic capsules, popcorn, paper, date stamp
Each capsule 11 x 8$^1/_2$ x 2"

16. *Talking Popcorn's First Words*, 2001
Cast bronze popcorn with plaque, velvet-lined wooden case
Closed dimensions: 3$^1/_2$ x 12 x 9$^1/_8$"
Collection of Sara Meltzer, New York

17. *Asteroid #4*, 2001
Gelatin silver print mounted on aluminum
29$^5/_8$ x 39$^5/_8$"

18. *Asteroid #5*, 2001
Gelatin silver print mounted on aluminum
29$^5/_8$ x 39$^5/_8$"

19. *Indecision on the Moon*, 2001
Audio for darkened room
31:35 minutes

20. *Natural Car Alarms*, 2001
Audio documentation loop with images

21. *Endurance*, 2002
Video with sound
9:18 minutes

22. *Self-portrait as Sir Ernest Shackleton*, 2002
Framed c-print
11$^1/_8$ x 9$^1/_8$ x 1$^5/_8$"

23. *Accent Elimination*, 2005
Six videos with sound, six monitors, three pedestals, video synchronizer, headphones, seating
Overall dimensions variable

24. *Grnad Opening*, 2006
Framed c-print
17$^1/_4$ x 24$^3/_4$"

25. *Grnad Opening Banner*, 2006
Vinyl
36 x 120"

26. *Austria*, 2006
Framed c-print
48$^1/_4$ x 35$^3/_4$ x 1"

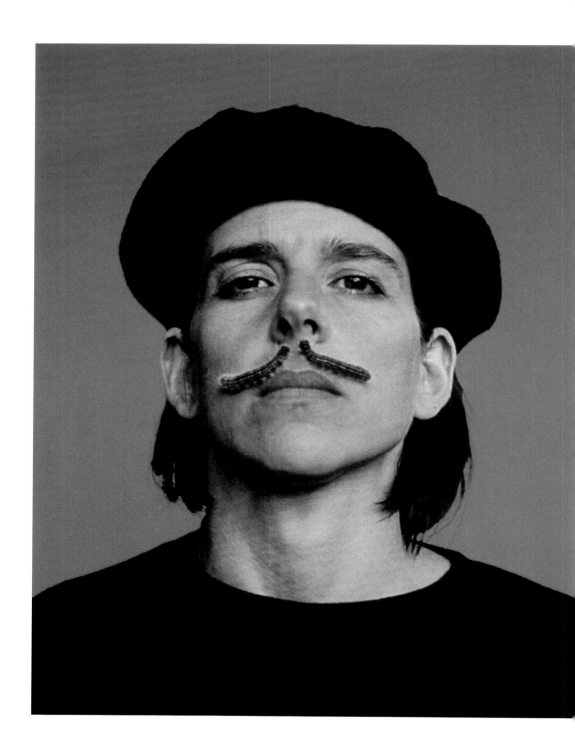

# NINA KATCHADOURIAN

Born in Stanford, California, in 1968
Lives and works in Brooklyn, New York

## Education

### 1996
Whitney Museum of American Art Independent Study Program, New York

### 1993
M.F.A., University of California, San Diego

### 1989
B.A., Brown University, Providence, Rhode Island

## Selected Solo Exhibitions

### 2006
*The Kinship Report*, Catharine Clark Gallery, San Francisco, August 3–
  September 2
*All Forms of Attraction*, The Frances Young Tang Teaching Museum
  and Art Gallery, Skidmore College, Saratoga Springs, New York,
  June 24–December 30
*Natural Misunderstandings*, John Michael Kohler Art Center, Sheboygan,
  Wisconsin, June 18–October 29
*Please, Please, Pleased to Meet'cha*, Wave Hill, Bronx, New York, June
  11–October 31
*Works Made in Finland by Nina Katchadourian*, Turku Art Museum, Turku,
  Finland, January 14–March 26

### 2005
*The Genealogy of the Supermarket and Other New Works*, Sara Meltzer Gallery,
  New York, May 21–June 25
*Sorting Strindberg*, IASPIS Galleriet, Stockholm, Sweden, January 21–March 3;
  Traveled to Stadsbiblioteket, Stockholm, Sweden; and Luna Kulturhus,
  Södertälje, Sweden

### 2003
*Animal Crossdressing, Uninvited Collaborations with Nature, and One Small Act
  of Endurance*, Catharine Clark Gallery, San Francisco, November 20,
  2003–January 3, 2004
*Natural Crossdressing, Uninvited Collaborations, and One Small Act of
  Endurance*, Debs & Co., New York, January 16–February 22

*Natural Crossdressing*, 2002
C-print
40 x 30"

## 2002

*Natural Car Alarms*, SculptureCenter, Long Island City, New York, June 29–
    December 14

*Geflickte Spinnweben, Paranormale Postkarten, Musikalischer Abfall (Mended
    Spiderwebs, Paranormal Postcards, Musical Garbage)*, ACC Galerie, Weimar,
    Germany, April 14–May 12

*Selected Works*, Hudson (Show)Room, Artpace, San Antonio, Texas,
    January 22–April 7

## 2001

*Talking Popcorn, Indecision on the Moon, and Eight Years of Sorting Books*,
    Catharine Clark Gallery, San Francisco, November 1–November 24

*Eight Years of Sorting Books*, Debs & Co., New York, September 7–October 13

*The Akron Stacks*, Akron Art Museum, Akron, Ohio, March 5–July 29

*Talking Popcorn, Paranormal Postcards, and Indecision on the Moon*, Debs & Co.,
    New York, January 13–February 24

## 1999

*Mended Spiderwebs and Other Natural Misunderstandings*, Debs & Co.,
    New York, January 7–February 13

## 1996

*Special Collections*, Athenaeum Music and Arts Library, La Jolla, California,
    September 21–November 16

## 1993

*Re-routing*, Linda Moore Gallery, San Diego, California, August 27–September 25

*Collected Work*, The Graduate Gallery, UC San Diego, June 8–11

## Selected Group Exhibitions

## 2006

*Moved by the Machine: Art Inspired by the Automobile*, Dubuque Museum of
    Art, Dubuque, Iowa, June 13–October 22

*Elusive Materials*, New Langton Arts, San Francisco, March 16–April 22

*When Artists Say We*, Artists Space, New York, March 8–April 29

*Welcome Home*, Sara Meltzer Gallery, New York, March 4–April 8

*Threads of Memory*, Dorsky Gallery Curatorial Programs, Long Island City,
    New York, February 5–April 17

*The Only Book*, The Center for Book Arts, New York, January 20–April 1

## 2005

*Library*, Contemporary Art Galleries, University of Connecticut, Storrs,
    Connecticut, November 14–December 16

*Performa05*, WKCR Radio, New York, November 3–November 21

*Figures of Thinking: Convergences in Contemporary Cultures*, Richard E. Peeler
 Art Center, DePauw University, Greencastle, Indiana, September 14–December 4
*Post Everything*, Rotunda Gallery, Brooklyn, New York, September 8–October 22
*Several Artists Consider Books*, Paul Kopeikin Gallery, Los Angeles, July 9–August 6
*New Tapestries*, Sara Meltzer Gallery, New York, June 30–July 27
*We Could Have Invited Everyone*, Andrew Kreps Gallery, New York, June 24–July 29
*Over + Over: Passion for Process*, Krannert Art Museum, Champaign, Illinois,
 January 29–April 3; Traveled to the Addison Gallery of American Art, Phillips
 Academy, Andover, Massachusetts, April 29–July 31
*Inside Out Loud: Visualizing Women's Health in Contemporary Art*, Mildred Lane
 Kemper Art Museum, St. Louis, Missouri, January 21–April 24
*Regarding Clementine*, Clementine Gallery, New York, January 6–February 5

## 2004

*Sixth Annual Altoids Curiously Strong Collection*, New Museum of Contemporary
 Art, New York, October 29–November 20
*Romantic Detachment*, P.S.1 Contemporary Arts Center, New York, October 16–
 November 7
*Harlem Postcards*, Studio Museum, Harlem, New York, October 15, 2004–
 January 4, 2005
*Bug–Eyed: Art, Culture, Insects*, Turtle Bay Museum, James and Pamela Koenig
 Art Gallery, Redding, California, August 7, 2004–March 27, 2005
*Open House: Working in Brooklyn*, Brooklyn Museum of Art, Brooklyn, New York,
 April 16–August 15
*One in a Million: Economies of the Self in Everyday Life*, Austrian Cultural Forum,
 New York, April 3–June 12
*Sacred Texts*, Minneapolis College of Art and Design, Minneapolis, Minnesota,
 February 28–March 28
*Lineaments of Gratified Desire*, Catharine Clark Gallery, San Francisco,
 February 19–March 27
*Birdspace: A Post–Audubon Artists Aviary*, Contemporary Art Center, New
 Orleans, Louisiana, January 10–March 23; Traveled to Norton Museum of Art,
 West Palm Beach, Florida, May 29–August 15; The Hudson River Museum,
 Yonkers, New York, October 9, 2004–January 2, 2005; Acadiana Center for the
 Arts, Lafayette, Louisiana, February 11–April 10, 2005; McDonough Museum
 of Art, Youngstown State Univeristy, Youngstown, Ohio, September 9–
 November 4, 2005; Tucson Museum of Art, Tucson, Arizona, January 21–
 March 12, 2006

## 2003

*The Luminous Image VI*, Collaborative Concepts, Beacon, New York, November
 22, 2003–February 22, 2004
*Living in a Cloud*, Royal Hibernian Academy, Dublin, Ireland, November 19, 2003–
 January 4, 2004
*Global Priority*, Herter Art Gallery, University of Massachusetts, Amherst,
 Massachusetts, November 6–December 19

*Synthetic Lightning: Complex Simulations of Nature*, The Center for
Photography at Woodstock, Woodstock, New York, November 1–December 21
*Exhibiting Signs of Age*, Berkeley Art Museum, Berkeley, California October 8,
2003–January 18, 2004; Traveled to Colby College Museum of Art, Waterville,
Maine, February 12–March 28, 2004
*Biennial Exhibition of Public Art*, Neuberger Museum of Art, Purchase, New
York, June 22–October 19
*s(how)*, Institute of Contemporary Art, University of Pennsylvania,
Philadelphia, Pennsylvania, May 3–July 27
*Sprout: An Exhibition Celebrating New Growth*, Catharine Clark Gallery, San
Francisco, March 20–April 19
*Ameri©an Dre@m*, Ronald Feldman Fine Arts, New York, February 22–April 5
*Territories: Mapping a Sense of Place*, Artspace, New Haven, Connecticut,
February 15–April 12; Traveled to Galerie für Landschaftskunst, Hamburg,
Germany, May 22–July 26

## 2002

*A Given Circumstance (gestures in situ)*, Arcadia University Art Gallery,
Glenside, Pennsylvania, November 14–December 20
*Nostalgia*, Art in General, New York, September 24, 2002–February 1, 2003
*Looming Large: Contemporary Weavers of the Vanguard*, Bedford Gallery,
Walnut Creek, California, September 10–November 3
*Books Without Pages*, Anne Reed Gallery, Ketchum, Idaho, August 1–August 30
*Words In Deeds*, Portland Institute of Contemporary Art, Portland, Oregon,
April 4–June 1
*Parting Line*, New Langton Arts, San Francisco, January 9–February 8

## 2001

*Presentness is Grace: Experiencing the Suspended Moment*, Arnolfini, Bristol,
United Kingdom, December 10, 2001–February 10, 2002; Traveled to Spacex,
Exeter, United Kingdom, February 20, 2002–April 13, 2002
*Amused*, Carrie Secrist Gallery, Chicago, Illinois, September 7–November 10
*Elsewhere*, Here Gallery, New York, July 14–September 1
*Let's Get To Work*, Susquehanna Art Museum, Harrisburg, Pennsylvania, July
15–October 20; Traveled to Rosenwald–Wolf Gallery, University of the Arts,
and Basekamp, Philadelphia, Pennsylvania, November 17–December 11
*The Cat's Away*, Sara Meltzer Gallery, New York, June 21–July 27
*Play's the Thing: Critical and Transgressive Practices in Contemporary Art*,
Whitney Museum of American Art Independent Study Program Exhibition,
Art Gallery of The Graduate Center, The City University of New York, New
York, May 25–July 8
*The World According to the Newest and Most Exact Observations: Mapping Art
and Science*, The Frances Young Tang Teaching Museum and Art Gallery,
Skidmore College, Saratoga Springs, New York, March 3–June 17
*Tenth Anniversary Show*, Catharine Clark Gallery, San Francisco, March 2–April 6
*THEM!*, Jay Grimm Gallery, New York, February 15–March 17
*Group Show*, Frumkin/Duval Gallery, Santa Monica

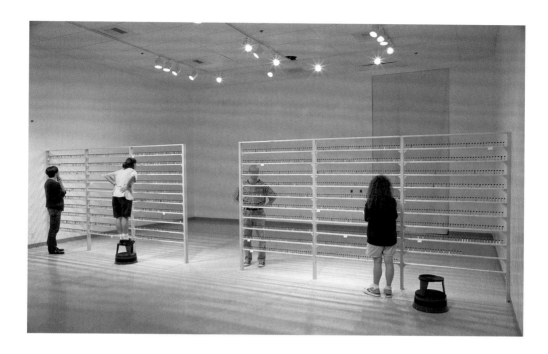

## 2000

*Aural Sex*, Catharine Clark Gallery, San Francisco, August 31–October 7

*Wildlife: A Field Guide to the Post–Natural*, Textile Museum of Canada, Toronto, Ontario, Canada, July 12–November 19; Traveled to Dunlop Art Gallery, Regina, Saskatchewan, Canada, July 14, 2001–September 1, 2001; Canadian Craft Museum, Vancouver, British Columbia, Canada; and Walter Phillips Gallery, The Banff Centre, Banff, Alberta, Canada, December 8, 2001–February 3, 2002

*From the Inside Out: Landscapes Reconsidered*, San Jose Institute of Contemporary Art, San Jose, California, July 7–August 12

*Human/Nature*, Caren Golden Fine Art, New York, June 28–July 28

*Anywhere But Here*, Artists Space, New York, June 1–July 22

*The Greenhouse Effect*, Serpentine Gallery, London, April 4–May 21

*Greater New York*, P.S.1 Contemporary Art Center, Long Island City, New York, February 27–May 14

*Millennium Bugs*, Islip Art Museum, Islip, New York, January 22–March 19

## 1999

*Interventions*, Catharine Clark Gallery, San Francisco, September 2–October 9

*Indoors/Outdoor*, Lönnström Art Museum, Rauma, Finland, June 12–August 8

*Alternative:Alternative*, Roebling Hall, Brooklyn, New York, April 9–May 12

*Rewriting the City*, Center for Curatorial Studies, Bard College, Annandale–on–Hudson, New York, May 9–May 23

*Stars of Track and Field*, Debs & Co., New York

*Collected Work*, 1993

Installation of 2000 glass vials containing materials gathered in response to the following question: "Person 'A' collects small objects. If the objects are collected at a constant rate, and each object is placed in a 1.5 dram bottle, what will they contain and how many will there be after exactly one week?"

Installation view, The Graduate Gallery, UC San Diego, 1993

71

## 1998

*Summer Show*, Debs & Co., New York, July 9–July 31

*Fukt*, Norrtälje Konsthall, Norrtälje, Sweden, July 4–August 8

*Syner/Sights/Näkyjä*, Knipnäs Konstnärskoloni, Ekenäs, Finland

## 1997

*Permutations*, Artists Space, New York, September 11–November 1

*Cartographers*, Museum of Contemporary Art, Zagreb, Croatia, June 8–July 27

*Runt om oss, Inom oss/Around us, Inside us,* Borås Konstmuseum, Borås,
    Sweden, May 7–August 17

*Songs of the Islands*, Audio in the Elevator, Art in General, New York,
    April 25–June 28

*You Can't Get There From Here*, Thomas Nordanstad Gallery, New York,
    January 18–February 16

## 1996

*Urban Perturbations*, Steffany Martz Gallery, New York, December 5,
    1996–January 11, 1997

*Constrictions,* Pierogi, Brooklyn, New York, May 4–May 27

*Subjective Play*, Spot Gallery, New York, April 17–May 11

*Maps, Charts and Routes,* Irvine Fine Arts Center, Irvine, California,
    January 26–March 10

## 1995

*Unchained: Artists from New York and Lithuania*, Galleri Kutschschtall,
    Potsdam, Germany

## 1994

*InSITE 94: CARPARK*, Southwestern College, Chula Vista, California,
    performance: August 31, exhibition: Southwestern College Art Gallery,
    Southwestern College, Chula Vista, California, September 28–October 30

*InSITE 94: Chloe's Case*, San Diego Museum of Natural History and Quint
    Gallery, San Diego, California, September 25–October 30

*The Box Show*, The Children's Museum of San Diego, San Diego, California

## 1993

*The Half Moon Bay Experiment*, Meyer Family Residence, Half Moon Bay,
    California, September 11–October 9

*The Games They Do with Art (Collaborative Experiments in Art),* San Diego
    Museum of Art, San Diego, California, January 22–February 21

## 1992

*InSITE 92: 30 Years 21 Minutes 17 Tapes*, Installation Gallery, San Diego,
    California, September 4–September 26

*Lahden 5. AV–biennale*, Lahti, Finland

# BIBLIOGRAPHY

## Selected Catalogues and Brochures

Batan, Martina, Sean Elwood, and Ronald Feldman. *Ameri©an Dre@m.* Exhibition catalogue. New York: Ronald Feldman Fine Arts, 2003.

Bender, Susan, and Ian Berry. *The World According to the Newest and Most Exact Observations: Mapping Art and Science.* Exhibition catalogue. Saratoga Springs, New York: The Frances Young Tang Teaching Museum and Art Gallery at Skidmore College, 2001. Essays by Bernard Possidente and Richard Wilkinson.

Berry, Ian. *All Forms of Attraction.* Exhibition catalogue. Saratoga Springs, New York: The Frances Young Tang Teaching Museum and Art Gallery at Skidmore College, 2006. Essay by Frances Richard.

Biesenbach, Klaus, et al. *Greater New York: New Art in New York Now.* Exhibition catalogue. New York: P.S.1 Contemporary Art Center and Museum of Modern Art, 2000.

Clark, Vicky A., and Sandhini Poddar. *Figures of Thinking: Convergences in Contemporary Cultures.* Richmond, Virginia: University of Richmond Museums, 2005.

Clausen, Barbara, Iris Klein, and Christoph Thun-Hohenstein. *One in a Million: Economies of the Self in Everyday Life.* Exhibition catalogue. New York: Austrian Cultural Forum, 2004.

Cole, Susanna, Erin Donnelly, Frank Motz, and Claire Tancons. *Play's the Thing: Critical and Transgressive Practices in Contemporary Art.* Exhibition catalogue. New York: Whitney Museum of American Art, 2001.

Corrin, Lisa, and Ralph Rugoff. *The Greenhouse Effect.* Exhibition catalogue. London: Serpentine Gallery, 2000.

Gerbracht, Grady, and Susan Jahoda, eds. "Global Priority." *Rethinking Marxism* 15, no. 3 (July 2003).

Glass, Ira, and Bill Zehme. *Amused.* Exhibition catalogue. Chicago: Carrie Secrist Gallery, 2001.

Gregg Duggan, Ginger, and Judith Hoos Fox. *Over + Over: Passion for Process.* Exhibition catalogue. Champaign, Illinois: Krannert Art Museum, 2005.

Harmon, Katharine. *You Are Here: Personal Geographies and Other Maps of the Imagination.* New York: Princeton Architectural Press, 2003.

Herbert, Martin, Catsou Roberts, and Lucy Steeds. *Presentness is Grace: Experiencing the Suspended Moment.* Exhibition catalogue. Bristol, United Kingdom: Arnolfini, 2001.

Kotik, Charlotta, and Tumelo Mosaka. *Open House: Working in Brooklyn.* Exhibition catalogue. Brooklyn, New York: Brooklyn Museum of Art, 2004.

Koscevic, Zelimir. *Cartographers.* Exhibition catalogue. Zagreb, Croatia: Museum of Contemporary Art, 1997.

*Living in a Cloud.* Exhibition catalogue. Dublin: Royal Hibernian Academy, 2004.

Nina Katchadourian and Julia Meltzer, *Wanted*, 1996 Newspaper advertisement and audio, 60 minutes

A fictional room for rent with the same proportions as a standard American jail cell (6 x 9 x 7 feet) was advertised for rent in the Village Voice. Callers were encouraged to "leave some information about yourself." The incoming calls were recorded and later played back into a room with the same proportions as the advertised space.

Mark, Lisa Gabrielle. *Wildlife: A Field Guide to the Post-Natural.* Exhibition catalogue. Toronto: Museum for Textiles, 2000.

*Mended Spiderwebs and Other Natural Misunderstandings.* Exhibition catalogue. New York: Debs & Co., 1999.

Mileaf, Janine, et al. *Inside Out Loud: Visualizing Women's Health in Contemporary Art.* Exhibition catalogue. St. Louis, Missouri: Mildred Lane Kemper Art Museum, 2004.

Mullin, Diane. *Sacred Texts: Sacred and Profane, the Words We Live By.* Exhibition catalogue. Minneapolis, Minnesota: MCAD Gallery, Minneapolis College of Art and Design, 2004.

*Natural Crossdressing, Uninvited Collaborations, and One Small Act of Endurance.* Exhibition catalogue. New York: Debs & Co., 2003.

Richard, Frances, Daniel Rosenberg, and Lytle Shaw. *Talking Popcorn, Paranormal Postcards, and Indecision on the Moon.* Exhibition catalogue. New York: Debs & Co., 2001.

Rubin, David S. *Birdspace: a Post-Audubon Artists Aviary.* Exhibition catalogue. New Orleans: Contemporary Arts Center, 2004.

*Runt om oss, inom oss/Around us, Inside us.* Exhibition catalogue. Borås, Sweden: Borås Konstmuseum, 1997.

Waters, John, and Bruce Hainley. *Art: A Sex Book.* New York: Thames and Hudson, 2003.

Watts, Patricia. *Bug-Eyed: Art, Culture, Insects.* Exhibition catalogue. Redding, California: Turtle Bay Exploration Park, 2004.

## Selected Articles and Reviews

"Ajan ihmisten ja muistojen jäljet." *Helsingin Sanomat* (4 February 2006).

Ante, Spencer. "Bi-Coastal." *Wired* 4, no. 8 (August 1996).

Baker, Kenneth. "Oh What a Tangled Web We Fix." *San Francisco Chronicle* (18 September 1999): B1.

Bhatnagar, Priya. "Renovating Nature: Nina Katchadourian at Debs & Co." *ArtByte* (April/May 1999).

Boucht, Charlotta. "Konstutflykt till Åbo." *Ny Tid* (17 February 2006): 2+.

Campbell-Johnston, Rachel. "Redoing What Comes Naturally." *The Times* (London) (12 April 2000): 21.

Chu, Ingrid. "Field Guide." *Canadian Art* 17, no. 4 (Winter 2000): 76.

Cotter, Holland. "New York Contemporary, Defined 150 Ways." *New York Times* (6 March 2000): E1+.

Dault, Gary Michael. "Animal Magnetism in a Post-Natural World," *Toronto Globe and Mail* (22 July 2000).

Dean, Corinna. "Carefully Cultivated." *The Architects' Journal* (11 May 2000): 48.

Dunne, Aidan. "Wide Open Spaces Beyond the Clouds." *Irish Times* (28 November 2003): 18.

Essoe, Jordan. "Smelling a Rat: Nina Katchadourian." *Stretcher.org* (18 February 2004).

Genocchio, Benjamin. "For Fun: The Maps That Lead
Nowhere." *New York Times* (23 March 2003) sec. 14CN: 9.
—. "Sometimes Birds are Symbols, Sometimes Just Birds."
*New York Times* (28 November 2004) sec. 14WC: 13.
—. "Using Illumination to Truly See." *New York Times*
(28 December 2003) sec. 14WC: 9.
Goddard, Dan R. "Artist Discovers Spider the Best Web
Master." *San Antonio Express-News* (4 February 2002): 4C.
Griffin, Tim. "Nina Katchadourian: Debs & Co." *Artext* no. 73
(May/July 2001): 81–82.
Hesser, Amanda. "Kings of Convenience." *New York Times
Magazine* (10 July 2005) sec. 6: 51.
Horton, David Harrison, and Kristin Miltner. "Aural Sex."
*Art Papers Magazine* 25, no. 1 (January/February 2001): 9.
Karr, Rick. "The Call of the Wild Car Alarm." *All Things
Considered.* National Public Radio (11 July 2002).
Katchadourian, Nina. "*Animal Crossdressing* and The *Mended
Spiderwebs* Series." *Atopia Journal: urg/üleistu* 4, no. 33
(October 2005): 2, 59–61.
—. "From the Sorted Books Project." *Open City* no. 16
(Winter 2002–03).
—. "Sorting Sharks." *Shark* 4 (Summer 2002): 119–123.
—. "The Geneaology of the Supermarket." *The Believer* 2, no. 12 (December
2004/January 2005): 60-61.
—. "Those Who Still Surround Him." *Satellite* 1, no. 1 (Spring 2006): 13–15.
Kempe, Jessica. "Boken I konsten, konsten I boken." *Dagens Nyheter*
(12 February 2005).
Kerr, Merrily. "Nina Katchadourian at Sara Meltzer Gallery." *Time Out New York*
no. 508 (23 June 2005).
Ketenjian, Tania. "Car Alarms." *Studio 360.* National Public Radio (5 October
2002 and 13 December 2003).
Kino, Carol. "The Emergent Factor—Greater New York, P.S.1 Contemporary
Art Center." *Art in America* 88, no. 7 (July 2000): 44–49.
—. "Nina Katchadourian at Debs & Co." *Art in America* 87, no. 10
(October 1999): 168.
Kuumola, Leena. "Minnets sköra spindelväv." *Hufvudstadsbladet*
(4 February 2006).
Lauterbauch, Ann. "Home Wrecker." *Nest* no. 6 (Fall 1999).
Levy, Ellen K. "Synthetic Lightning: Complex Simulations of Nature."
*Photography Quarterly*, no. 88 (2004): 8-10.
"Luonto ja ihminen kasvotusten Turun taidemuseuossa." *Turun Sanomat*
(14 January 2006).
Mahoney, Robert. "Human/Nature." *Time Out New York* no. 253 (27 July 2000):
58.
Melkonian, Neery. "The World According to Nina Katchadourian." *Ararat* 44,
no. 184 (Fall 2005): 6–8.

*Chloe*, 1994
Taxidermied pet dog, pillow,
towel, and carpet in vitrine

Proposal for Museum of
Natural History, San Diego:
Domestic animal to be
presented with the museum's
own display and informational
systems. (unrealized)

Moody, Tom. "Nina Katchadourian at Debs & Co." *Artforum* 37, no.10
(Summer 1999): 158.

Mumford, Steve. "Nina Katchadourian at Debs & Co." *Review Magazine* 4, no. 8
(15 January 1999).

Ollman, Leah. "Renewed Energy and Ingenuity at Installation." *Los Angeles
Times* (23 September 1992): F1+.

Packer, William. "London's Green and Pleasant Land." *Financial Times* (London)
(11 April 2000): 20.

Phillips, Patricia C. "Inscription and Testimony: Public Art and Shared
Experience." *Sculpture* 21, no.8 (October 2002): 44–49.

Phillips, Tom. "Presentness Is Grace." *Venue* (7 December 2001): 79.

Pincus, Robert L. "Whimsical Cartographer: Katchadourian borrows freely to
make her art." *San Diego Union Tribune* (2 September 1993): 26.

Plagens, Peter. "Sculpture Made to Border." *Newsweek* (31 October 1994): 64.

"Presentness is Grace: Experiencing the Suspended Moment." *Contemporary* no.
35 (January 2002).

"Presentness is Grace; Arnolfini, Bristol." *Frieze*, no. 67 (May 2002): 94.

Reily, Maura. "Nina Katchadourian at Debs & Co." Review. *Art in America* 91,
no. 6 (June 2003): 122.

Richard, Frances. "Nina Katchadourian at SculptureCenter." *Artforum* 41, no. 2
(October 2002): 153.

Rosenberg, Daniel. "One Small Step (for Nina Katchadourian)." *Art Journal* 61,
no. 3 (Fall 2002): 32–39.

Safe, Emma. "Presentness is Grace: Experiencing the Suspended Moment."
*Art Monthly* no. 253 (February 2002): 24-25.

Salazar Leopold, Lillian. "Parked Cars Can Produce a Lot of Art." *San Diego
Union Tribune* (6 September 1994): E1+.

Schwendener, Martha. "Nina Katchadourian, 'Talking Popcorn, Paranormal
Postcards and Indecision on the Moon'." *Time Out New York* no. 282 (15
February 2001).

Shinn, Dorothy. "Where Popcorn Talks and Puns are Piled High." *Akron Beacon
Journal* (11 March 2001): D8.

Shulevitz, Judith. "Young American Art: A Web Tour." *Slate Magazine*
(2 March 2000).

Smith, Roberta. "We Could Have Invited Everyone." *New York Times*
(15 July 2005).

Sozanski, Edward. "Take a look, and then another." *The Philadelphia Inquirer*
(8 December 2002).

Stern, Steven. "Nina Katchadourian, 'Natural Crossdressing, Uninvited
Collaborations and One Small Act of Endurance'." *Time Out New York* no. 386
(20 February 2003): 51.

Strauss, Neil. "The Walls Speak: Constrictions at Pierogi 2000." *New York Times*
(16 May 1996): C15+.

Volk, Gregory. "Nina Katchadourian at Sara Meltzer." *Art in America* 94, no. 1
(January 2006): 114.

Von Wright, Heidi. "Ett med naturen." *Åbo Underrättelsen* (11 February 2006): 15.

Westbrook, Lindsey. "'Animal Crossdressing, Uninvited Collaborations with Nature, and One Small Act of Endurance." *San Francisco Bay Guardian* 38, no. 11 (10 December 2003): 75.

Zimmer, William. "Sculpture Sprouting on Campus Becomes, Literally, an Art Exercise." *New York Times* (13 July 2003): WE8+.

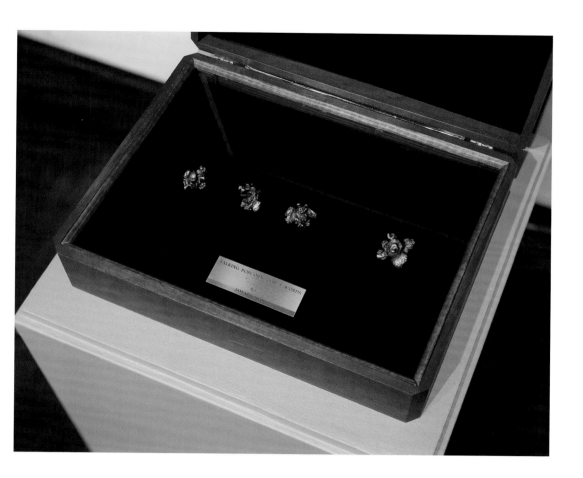

*Talking Popcorn's First Words*, 2001
Cast bronze popcorn with plaque,
velvet-lined wooden case
Closed dimensions: 3$^1/_2$ x 12 x 9$^1/_8$"
Collection of Sara Meltzer, New York

## ACKNOWLEDGMENTS

*All Forms of Attraction*, the eleventh in the Tang Museum's Opener series brings together thirteen years of artist Nina Katchadourian's investigative and expansive artworks. Working without limitations often imposed by traditional media definitions, Nina has crafted a post-studio process that has lead her into jungles, up into trees, down to sidewalks, through libraries, and to many unusual spots on the globe to uncover details of our world that we don't normally focus on. She presents the often humorous and always engaging results of her experiences using a wide variety of forms from sound and video to photography and installation. We are provoked in the right ways when viewing these seductive and curious displays and at the best moments leave with more questions than answers.

I would like to extend our sincere thanks to many individuals that helped make this project a success. First, thanks to the lenders who allowed us to ask questions with their works at the Tang—thanks to Emilie Clark and Lytle Shaw, Colby College Museum of Art, Nick Debs, Susanne Grousbeck, Sara Meltzer, Richard and Lenore Niles, Ralph and Sheila Pickett, Sara Meltzer Gallery and the artist herself. A sincere thank you to each of the funders of the series who deserve special recognition for their continued support of these projects - thanks to the Overbrook Foundation, The New York State Council on the Arts, the Laurie Tisch Sussman Foundation, and the Friends of the Tang.

The entire staff of the Tang Museum contributed to the success of this project—thanks to Ginger Ertz, Lori Geraghty, Elizabeth Karp, Susi Kerr, Gayle King, Patrick O'Rourke, Barbara Schrade, Kelly Ward and Tang Director John Weber for their support. Special thanks to Senior Preparator Torrance Fish, Head of Installations, Nicholas Warner, and installation crew Dave Brown, Sam Coe, Steve Kroeger, Julian Lorber, Dan O'Connor, and Cynthia Zellner for their careful and creative work on each of the pieces in the exhibition. Thanks to Curatorial Assistant Ginny Kollak and student interns Kristin Sutton, Caitlin Woolsey, Justin Hirsch, Helena Sanders, Julia Ferguson, and India Clark for their research and attention to details throughout the project.

Thanks to designer Bethany Johns for her magnificent work on this book that compiles much of Nina's work to date, and to Arthur Evans who worked diligently to capture the diverse works with his sensitive photography. Very special thanks to Nick Debs, who introduced me to Nina's works so many years ago, and to her current representatives Catharine Clark in San Francisco and Sara Meltzer in New York for their great spirit of collaboration and support. Thanks to Rachel Gugelberger and Jeffrey Walkowiak at Sara Meltzer Gallery in New York for attending to so many details along the way and to Sina Najafi for his steady support and advice.

To Nina I offer the appreciation of all of us at the Tang for her wonderful work that excited our imaginations and kept us in constant conversation every day. During the course of the exhibition she presented informal talks, formal lectures, gallery tours, played guitar and sang, and even spun records for the students. She left an important trace here at Skidmore and we are very grateful for her reminder to pay close attention and notice more of what is all around us.

—IAN BERRY

Working with Ian Berry and the staff and crew at the Tang has probably spoiled me forever. I am deeply grateful for the collaborative spirit with which Ian approached this show, and for his good humor, his flexibility, his creativity, and his faith in my work. Everyone at the Tang has treated my work with such care, consideration, and generosity, and the show has been installed and maintained according to such high standards that they often surpassed my own.

Putting together a show like this is an enormous privilege but it also comes with a fair amount of anxiety about what it might feel like to see all these years of work brought together. My effusive thanks go to all of those people who have supported me personally and professionally through the years and also specifically during the time this show was being put together. My friends and family are supportive of me in ways that are really too numerous to name. I am lucky and grateful to live amongst your brains and hearts.

—NINA KATCHADOURIAN

This catalogue accompanies the exhibition

OPENER 11

NINA KATCHADOURIAN:

*ALL FORMS OF ATTRACTION*

The Frances Young Tang Teaching Museum and Art Gallery at Skidmore College,
Saratoga Springs, New York
June 24–December 30, 2006

The Frances Young Tang Teaching Museum and Art Gallery
Skidmore College
815 North Broadway
Saratoga Springs, New York 12866
T 518 580 8080
F 518 580 5069
www.skidmore.edu/tang

NYSCA

This exhibition and publication are made possible in part with public funds from
the New York State Council on the Arts, a state agency, The Laurie Tisch Sussman
Foundation, The Overbrook Foundation, and the Friends of the Tang.

Front cover:
*Artificial Insemination*, 1998
C-print
20 x 20"
Courtesy of the artist

Page 1:
*Bali Bird House*, 2006

Back cover:
*Austria*, 2006 (detail)
Framed c-print
$48^1/_4$ x $35^3/_4$ x 1"
Courtesy of the artist and
Sara Meltzer Gallery

Photography:
All photographs by Arthur Evans except the following:
Front cover, pages 1, 9, 10, 19, 25, 27, 42: Nina Katchadourian
Pages 20–21, 62–63: Herman Feldhaus
Pages 23, 66: Bas Ducander
Pages 26 (top), 75: Philip Scholz Rittermann
Page 43: Frank Oudeman
Page 71: Tim Nohe

Designed by Bethany Johns
Printed in Germany by Cantz